Contents

Portrait of an Artist

Successful painter, author and teacher, Alwyn Crawshaw was born in Mirfield, Yorkshire and studied at Hastings School of Art. He now lives in Norfolk with his wife June, who is also an artist.

Alwyn is a Fellow of the Royal Society of Arts, and a member of the British Watercolour Society and the Society of Equestrian Artists. He is also President of the National Acrylic Painters Association, an

◀ Alwyn Crawshaw working outdoors.

honorary member of the United Society of Artists and is listed in the current edition of *Who's Who in Art*. As well as painting in watercolour, Alwyn also works in oil, acrylic and occasionally pastel. He chooses to paint landscapes, seascapes, buildings and anything else that inspires him. Heavy working horses and winter trees are frequently featured in his landscape paintings and may be considered the artist's trademark.

This book is one of eight titles written by Alwyn Crawshaw for the HarperCollins *Learn to Paint* series. Alwyn's other books for HarperCollins include: *The Artist At Work* (an autobiography of his painting career), *Sketching with Alwyn Crawshaw*, *The Half-Hour Painter*, *Alwyn Crawshaw's Watercolour Painting Course*, *Alwyn Crawshaw's Oil Painting Course*, *Alwyn Crawshaw's Acrylic Painting Course*, *Alwyn & June Crawshaw's Outdoor Painting Course* and *You Can Paint Watercolour*.

Television appearances

To date Alwyn has made eight television series. These include *A Brush with Art*, *Crawshaw Paints on Holiday*, *Crawshaw Paints Oils*, *Crawshaw's Watercolour Studio*, *Crawshaw Paints Acrylics*, *Crawshaw's Sketching & Drawing Course* and *Crawshaw Paints Constable Country*, and for each of these Alwyn has written a book of the same title to accompany the television series. His latest television series, *Crawshaw's Watercolour Cruise*, was filmed in Spain and the Middle East.

Alwyn has been a guest on local and national radio programmes and has appeared on various television programmes. In addition, his television programmes have been shown worldwide, including in the USA and Japan. He has made many successful videos on painting and is also a regular contributor to the *Leisure Painter* magazine and the *International Artist* magazine. Alwyn and June organize their own successful and very popular painting courses and holidays.

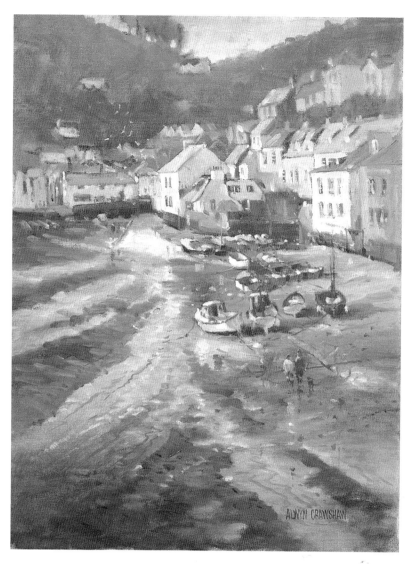

▲ **Polperro, Cornwall**
oil on canvas
40 x 30 cm (16 x 12 in)

They also co-founded the Society of Amateur Artists, of which Alwyn is President.

Alwyn's paintings are sold in British and overseas galleries and can be found in private collections throughout the world. His work has been favourably reviewed by the critics. *The Telegraph Weekend Magazine* reported him to be 'a landscape painter of considerable expertise' and the *Artists and Illustrators* magazine described him as 'outspoken about the importance of maintaining traditional values in the teaching of art'.

Why Paint Landscapes?

It is not hard to understand why so many artists over the centuries have painted landscapes. As a subject for painting, landscape is never ending – there is always something to see and paint. You can stand in the countryside on the same spot and from each of the four compass points see a different picture. Now add to that a sunrise, sunset, daytime, night-time, a sunny day, a windy day, a rainy day, a misty day and so on. Then add the four seasons of the year to the permutation. You can see that from just one viewpoint you can paint dozens of different pictures during the year.

Not only are there always subjects for the landscape painter to paint, but there is also the call of the 'great outdoors'. At times we all have the feeling of wanting to get outside. We have the urge to get close to nature: to see the vast landscape in front of us with windswept clouds, or the tree fallen half across an old cart track that has long since had its last horse and cart rumbling down its rutted surface.

A sense of inspiration

All our senses, not just our visual sense, are with us whenever we are outside. Our sense of touch allows us to feel the wind, the warmth of the sun or the sting of nettles. Our sense of hearing also plays a big part in enjoying or 'seeing' the countryside: the birds singing, running water, wind blowing through the trees, and so on. But above all, apart from

▼ **A Soft Blanket of Snow**
watercolour on Bockingford watercolour paper 200 lb Not
38 x 50 cm (15 x 20 in)
My original sketch for this watercolour, although done in winter, was not a snow scene. One of the advantages of working indoors is that you can add details like snow using your memory and imagination. Of course, I have sketched and painted in the snow many times but to get the best results it really does help if you are warm and comfortable!

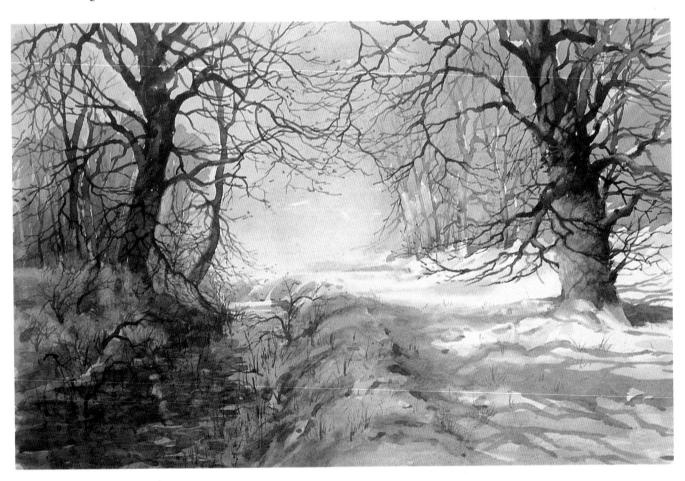

seeing the countryside, the sense of smell gives me the most inspiration for painting landscape: the scent of long, sweet summer grass; the dank aroma of wet autumn leaves; the smell of a dusty road after a quick summer shower of rain.

Painting indoors

Of course, when it's impossible to go out, you can paint indoors from your imagination or sketches you have done outdoors. One great advantage of painting indoors is that it gives you more time to consider the progress of your painting and to change parts of it if you feel that this is necessary. Most of the Old Masters worked outside on smaller studies and then used their sketches for information and inspiration for larger indoor paintings.

Types of sketch

The word 'sketch' can mean many different things from a rough drawing to a finished picture. I believe there are three distinct and very practical types of sketch:

Enjoyment sketch

A drawing or painting worked on location and done simply to enjoy the experience.

Information sketch

A drawing or painting done for the sole purpose of collecting information

Atmosphere sketch

A drawing or painting worked for the sole purpose of getting atmosphere and mood into the finished result. It can then be used at home for atmosphere and mood information, or as an inspiration sketch for an indoor landscape painting.

All sketches, whether they are drawings or paintings, can be used as 'finished' works. In fact, some artists' sketches are preferred to their finished paintings. We will cover the subject of sketching in more depth later in the book.

▲ **Afternoon Walk with the Dogs**
oil on canvas
50 x 75 cm (20 x 30 in)
This oil painting was also done at home using a location pencil sketch. Because you haven't got colours to copy from when working from such a sketch, I suggest you also take a photo of the scene to guide you. As you progress and gain experience, you will find your visual memory helps you to remember colours when you work indoors.

7

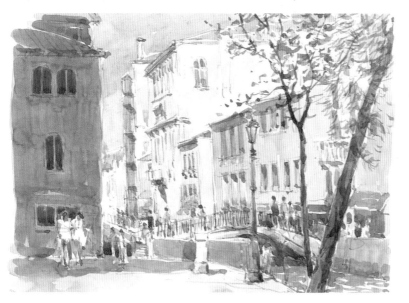

say with great excitement: 'Look at that – isn't it fantastic? It would make a perfect watercolour or oil painting', or whichever medium suited the scene.

Carry a sketchbook

When you are out, carry a small sketchbook with you. If you have time on your hands, start drawing. If you are aware of wanting to sketch, you will find plenty of opportunities coming your way. If they don't, put a little pressure on yourself and make some – where there's a will, there's a sketch!

I wrote this book to help you to paint landscapes and, to do this, I decided to work in watercolour and oil. If you want to learn more about these mediums, three of my books in this series cover each medium in great detail. These are: *Learn to Paint Watercolours*, *Learn to Paint Outdoors in Watercolour* and *Learn to Paint Oils for the Beginner*.

In the following lessons and exercises there is no underlying reason why a painting is done in watercolour or oil. If there is any specific reason, it is that I feel the subject matter is more suited to that particular medium.

▲ Venetian Canal
2B pencil and watercolour on cartridge paper
20 x 28 cm (8 x 11 in)
It was a gorgeous day and I was sitting comfortably on a bench by the side of the canal when I painted this scene. The air was full of the sounds of lapping water, boatmen calling and holidaymakers enjoying themselves.

Get out and about!

The true inspiration for landscape artists is Mother Nature. Never forget this. Try to go out and paint as much as possible. Observe – even when you are a passenger in a car or train, look at what you see with the object of painting it.

Art school taught me to observe and translate what I saw into a painting (in my mind!), and I am still doing this. I could be walking and talking with my family about anything other than painting, when I stop and

◄ 'You Are Always Watching the Birds!'
Oil on canvas
60 x 91 cm (24 x 36 in)
I used my pencil sketches of horses done at horse shows for this painting but the landscape was pure imagination! Working on an oil this size gives you plenty of time to rethink areas that are not working out – something that is very difficult and often impossible to do with a watercolour.

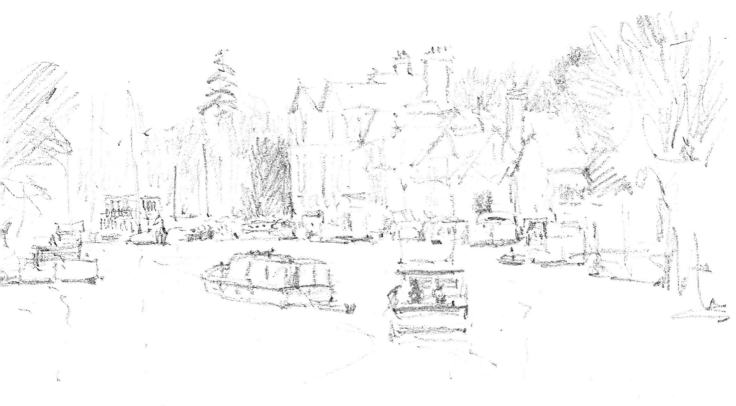

Above all, enjoy yourself

When you are out painting, try not to become too obsessed with your work or you will miss the joy of being outside and painting. Whatever you do, make your painting enjoyable. There are going to be times when nothing goes right and you will blame everything from your paintbrush to the weather. This happens to all of us, but remember that whatever you put down on paper when working directly from nature is spontaneous, and something will always be learned, no matter how brief the encounter. Never throw away a poor sketch or painting; every picture tells a story. Even if it says: 'Don't do it this way again!', it will serve as a constant reminder to you!

Before you are tempted to start painting, I would like you to relax and to carry on reading this book. I will take you through things stage by stage, working very simply to start with, and then progressing to a more mature form of painting. When you do start the lessons and exercises, enjoy them. If you find some parts difficult, don't get obsessed with the problem. Go on a stage further and then come back – seeing the problem with a fresh eye will make it easier to solve.

I did the impromptu enjoyment sketch (above) when June and I were cruising with our friends on the river near where we live. As we passed the buildings and boatyards, I looked behind me, saw the scene and was inspired! We were moving very slowly, so I had ten minutes to sketch before the view was too far into the distance. Standing while holding my sketchpad, combined with the movement of the boat, made drawing clean, definite lines almost impossible but I was very pleased with the result and, more than that, I had just enjoyed one of those memorable moments that the landscape painter lives for – to see a scene, to be inspired, to sketch or paint it, and to feel really contented.

Start simply

If you are a beginner, don't attempt anything too ambitious to start with. To have spirit and determination is fine, but to try for the unattainable and then fail to reach your desired goal could ruin your confidence and put you back a long way. But if you have a go at a simple subject, and it comes off, this will boost your confidence enormously. Remember the old saying: 'Don't run before you can walk'. Good luck!

▲ **The Swan Hotel, Horning, Norfolk Broads**
2B pencil on cartridge paper
20 x 28 cm (8 x 11 in)

Watercolour Equipment

Crimson Alizarin

Yellow Ochre

French Ultramarine

Cadmium Red

Cadmium Yellow Pale

Coeruleum

Hooker's Green Dark

▲ These are the watercolours I have used in this book.

All professional artists have their own preferences regarding the materials they use: brushes, colours, paper and so on. In the end, the choice must be left to you to make from your personal experience but, to get the best results, buy the best materials you can afford. If you are a beginner, I would suggest you use the materials I have used throughout this book. I have kept them simple and uncomplicated to help you. Incidentally, I use these same materials for all my watercolour painting.

Colours

There are two qualities of watercolour paints. The best ones are called artists' quality, while the less expensive ones are called students' quality. Daler-Rowney manufacture Aquafine Georgian watercolours, which are an excellent student quality.

Colours come in tubes or pans but I suggest that you use pans to start with – it is much easier to control the amount of paint you can get on your brush than from paint squeezed out of a tube onto a palette. Pans come in paint boxes and you use the lid of the box as your palette, see mine (top right). I use pans for all my work. The colours I normally use and have used in this book are shown (left) and I will show you in more detail about colours and colour mixing on page 12.

Brushes

Brushes are the tools of the trade. Like a pen with handwriting, they show the difference between one person's work and another. It is the brushes that make the marks that make the painting. They are so important! Brushes made from sable hair are the best quality you can buy for watercolour. Brushes made with man-made fibres (Dalon is the brand name for an excellent range of brushes used by professionals and amateurs) are less expensive. Another good range of brushes is Expression; this is a mix of red sable and synthetic filaments. These are more expensive

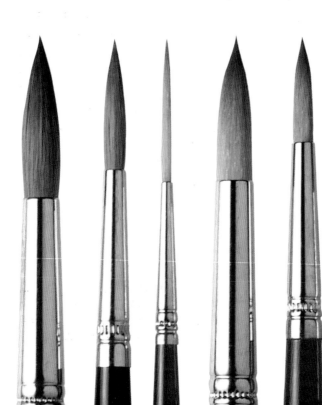

◄ There are many different types of brushes, but here are some that I strongly recommend. From left to right (actual size): Series 40 Kolinsky sable round brush No. 10; Series 43 sable round brush No. 6; Series D99 rigger brush No. 2; Series D77 round brush No. 10; Series D77 round brush No.6; Series E85 Expression round brush No. 10.

than the Dalon brand. I use three brushes. These are a Daler-Rowney Series 40 round sable No. 10 (my 'big brush'), a Series 43 round sable No. 6, and a Dalon Series D99 rigger brush No. 2, which I use for small 'line' work. It is ideal for tree branches. A selection of brushes that I recommend are shown (below left) but at first you only need one No. 10 and one No. 6, plus a rigger.

▲ My watercolour box

Paper

I have used three different types of paper in this book, but the one I have used the most, an excellent and inexpensive one, is Bockingford watercolour paper 200 lb Not. The word 'Not' describes the surface and it means it is not a rough surface. The weight of the paper (200 lb), denotes the thickness of the paper. If the paper had a rough surface, it would show the word 'Rough' after the weight, e.g. Bockingford watercolour paper 200 lb Rough. This applies to almost all watercolour papers. Another excellent paper is Waterford. This has a harder surface than Bockingford and allows you to paint more washes over washes without disturbing the dry wash underneath. Finally, cartridge drawing paper is very good for painting on. I often use it for small (up to A3 size) outdoor work. It has only one surface, which is smooth. You will find out what each paper offers you only through practice and experimenting. All these papers can be bought by the sheet, 50 x 75 cm (20 x 30 in), or in smaller books or pads.

Other materials

Whether or not you use an easel is up to you. I don't use one. When I am working outdoors, I rest my pad or board (with my paper pinned to it) on my knees. When indoors, I work on a table. You will definitely need a putty eraser, a water holder and, finally, a 2B and a 3B pencil. Naturally, as you progress and become more experienced, you will want to try different colours, different papers and other brushes. This can be very exciting but, for the moment, try to be patient!

◀ The three types of paper I have used in this book for watercolour are (from the top): Bockingford watercolour paper 200 lb Not; cartridge drawing paper, and Waterford watercolour paper 200 lb Not.

Colour Mixing in Watercolour

If you are a beginner, I know this chapter on mixing colours will be very exciting, and – better still – easier than you think. If you have painted before, use it as an excuse to get back to basics; to experiment and enjoy a fresh and exciting journey around your paintbox.

Primary colours

There are countless colours in a landscape, but you can get almost any colour you need from just the three primary colours: red, yellow and blue. There are different reds, yellows and blues to help you mix the colours you want, but generally you should be able to paint a picture using just one of each of the primary colours.

Although there are three primary colours, many colours that we make are mixed from just two. For instance, green is mixed from yellow and blue. If you want a warmer (browner) green, you will need to add a little of the third primary colour, red, to your mix. This is where colour mixing gets slightly more complicated – for instance, if you tried to get the warm green by mixing equal parts of yellow, blue and red, you would make a dark mud colour!

So how do you judge the correct quantity to mix to get the desired colour? You will discover this by practising but always remember this: the first colour you put onto your mixing area must be the predominant colour you are trying to create. For example, if you want to mix, say, a reddish-orange, you should put red into the mixing area because red is the predominant colour, and then add a smaller amount of yellow. If you start with yellow in the mixing area and then add a smaller amount of red, you will make a yellowish-orange. You could eventually get a reddish-orange by adding more and more red, but you would mix more paint than you needed, and it would be very frustrating and time-wasting. To make your colours lighter, add water to the paint.

Local colours

Although you can paint a picture using three primary colours, a good reason for having different primaries is to be able to use them for local colours. A local colour is the colour of an individual object: for example, a particular red car, blue boat, yellow flower, etc.

Using the right colour is important when you are painting a picture but don't worry about it or keep re-mixing if your colour is a little different from the real-life colour. You don't have to be exact. Everyone can learn to mix colours. Keep practising – you will experience a wonderful feeling of success when you are able to mix the colours you need.

Always note the first colour shown on the exercise or specified in the text when you are mixing colours. This is usually the predominant colour of the mix, with other colours added in smaller amounts.

You may have noticed that my palette doesn't include black. Some artists use black, others don't. I am one of those who doesn't. I believe it is too flat – a dead colour, in fact – so I mix my blacks from the primary colours.

Relax when you are learning to mix colours and you will get better results. It doesn't matter what the result looks like – it's only practice.

▶ Watercolour painting colour mixing chart

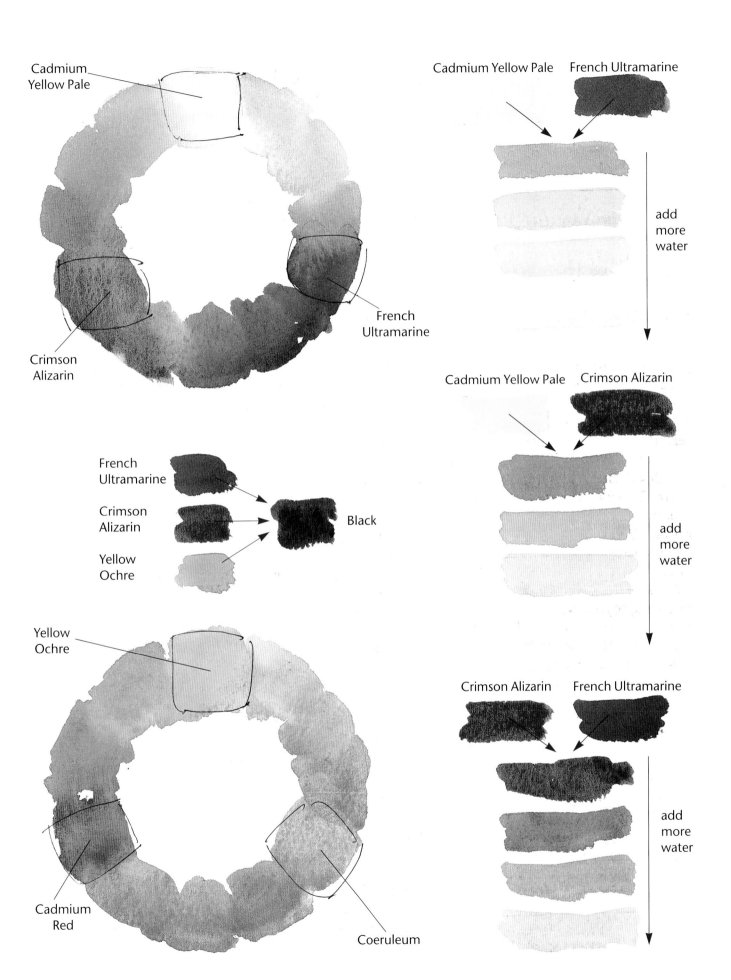

Cadmium
Yellow Pale

French
Ultramarine

Crimson
Alizarin

French
Ultramarine

Crimson
Alizarin

Yellow
Ochre

Black

Yellow
Ochre

Cadmium
Red

Coeruleum

Cadmium Yellow Pale French Ultramarine

add
more
water

Cadmium Yellow Pale Crimson Alizarin

add
more
water

Crimson Alizarin French Ultramarine

add
more
water

Watercolour Techniques

If you haven't painted in watercolour before, here are some basic principles to get you started. First of all, remember that watercolour is transparent, and therefore the background surface (paper or paint) shows through. Always start by painting lighter colours first.

As you progress through the picture, build up your dark areas by painting darker tones over lighter tones, when they are dry. Because it is transparent, you can't make a dark colour lighter by painting a lighter colour over it. Your light colours or light areas in a painting are left either as unpainted white paper, or simply by lighter tones that have not been made darker by adding more paint on top.

Follow the arrows

On these pages, I have shown some very basic watercolour techniques and where I have used these techniques in paintings. I have used two types of arrow in various places in this book to help you understand the movement of the brush strokes. The red arrow shows the direction of the brush stroke, and the blue

When working indoors, you can dry the paint with a hairdryer. Hold it 45 cm (18 in) away to start with, then closer as the paint is drying.

arrow indicates the movement of the brush in relation to the paper – from top to bottom or bottom to top.

Painting a wash

The secret is to use plenty of water when you paint a wash (below left). Take the loaded brush from left to right in one stroke. Continue from the left again, letting the first stroke run into the second and so on down the paper. When working in watercolour, your painting surface must always be at an angle, to allow the paint to run down the paper.

▼ I used washes for the sky and the shadows on the snow under the trees.

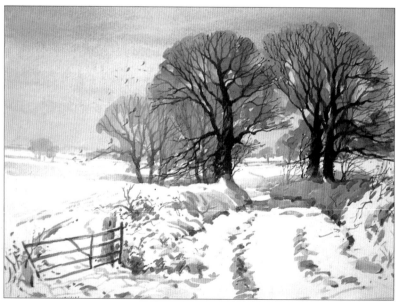

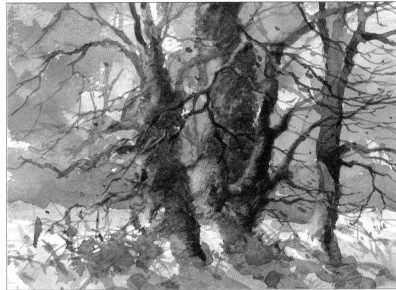

Lifting out

You can lift out with a paper tissue, a sable, Dalon or Bristlewhite brush (above). The stiffer the bristles of your brush, the more paint you will be able to lift out with it.

Wet-on-wet

If you add another colour into the paint while it is wet, the two colours will mix and merge. This technique is called 'wet-on-wet' (below). Once the paint has started to dry on your painting surface, don't apply any more paint on it, or you will get some very strange effects (although you might choose to experiment with and use these when you have plenty of experience!).

Once the paint is completely dry, you can apply another colour on top of it. Then the colours will not mix and hard edges will be created. The wet-on-wet technique is used throughout a watercolour painting.

There are many more subtle watercolour effects – the most exciting ones will be those you create for yourself as you gain experience. By using these, your paintings will become very much your own.

▲ The tree trunks and some branches were made lighter by lifting out with a Bristlewhite brush.

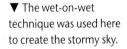

▼ The wet-on-wet technique was used here to create the stormy sky.

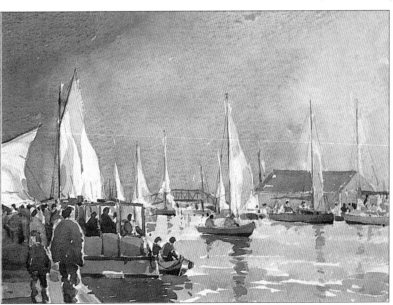

Oil Equipment

As with watercolour materials, oil painting materials are the choice of the individual artist. But use the ones I have used for this book and it will be less complicated and easier to follow, especially with so many different brushes, paints, mediums and painting surfaces (grounds) on the market today. Remember, you can always add to or subtract from these materials when you gain more experience.

Colours

All oil colours come in tubes and small amounts are squeezed out onto an artist's palette. Like watercolour, there are artists' quality and students' quality. I have used Georgian oil colours, a students' quality, throughout the book and I am sure you will find them excellent.

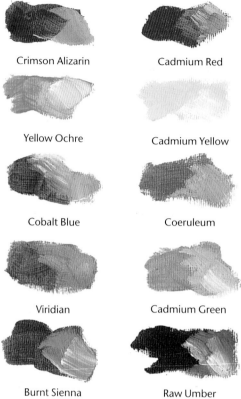

Crimson Alizarin

Cadmium Red

Yellow Ochre

Cadmium Yellow

Cobalt Blue

Coeruleum

Viridian

Cadmium Green

Burnt Sienna

Raw Umber

◀ These ten oil colours, together with Titanium White, are the ones I have used in this book.

I explain about colour mixing in oil on page 18, and the colours I used for this book are illustrated above.

Brushes

As I said earlier, the brushes make the marks on the canvas, so the choice of brush is very important. The traditional oil painting brush is usually made from hog bristle, but today man-made fibres (nylon) are used – not necessarily to replace the hog bristles, but to allow the artist more scope. There are three basic brush shapes: round, filbert and flat. I prefer to use a flat one for general work, a

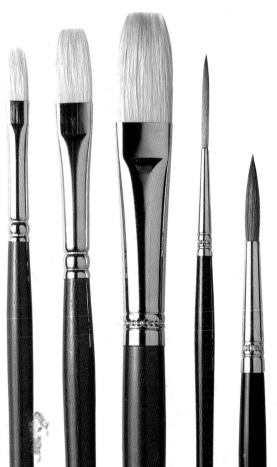

◀ These are the brushes I have used for the book (from left to right): Daler-Rowney Bristlewhite Series B48; sizes 2, 4 and 8; Series D99 rigger No. 2; Series 43 sable No. 6.

small round sable or Dalon brush for detail work, and a 'rigger' for line work. The brushes I have used for the book are illustrated (below left).

Painting surfaces

The traditional painting surface (support) for oil painting is canvas but over the years new surfaces have emerged which are cheaper and allow the artist more choice. Some of the surfaces I have used in the book are reproduced actual size (right), and I have applied some paint to help show you the grain of each surface. Unless the support has been primed by the manufacturer, you should prime all surfaces, especially absorbent ones like paper or MDF, with two or three coats of Gesso Primer or Acrylic Primer. I use all of the surfaces illustrated. Experiment and find the one that suits you and your pocket. Of them all, canvas is usually the most expensive.

Mediums

Don't be concerned about all the different mediums there are for oil painting on the market. We will keep it simple. You want a general purpose cleaner for your brushes and palette. Use turpentine substitute or white spirit. For mixing with your paints to thin the paint as you use it, use Daler-Rowney Low Odour Thinners; this is excellent and it doesn't smell. To make the paint dry more quickly, I use Alkyd Medium. As white paint is mixed with most colours, I add some Alkyd Medium into my white with a palette knife before I start painting. The white then becomes a general drying agent.

Other materials

A lightweight easel is the best one for outdoor work and can also be used indoors. If you don't have an easel to start with, use a kitchen chair. Rest your canvas against the backrest and use the seat to put your paints on. Manufactured artists' palettes can be made of

◀ Some oil painting surfaces (supports): top left: canvas panel, medium grain; top right: canvas; bottom left: primed MDF; bottom right: primed Waterford watercolour paper 300 lb Rough.

wood or plastic, and you can use either. You will need a palette knife for mixing or cleaning your palette, and plenty of rags to clean your brushes and the mixing area of your palette after use. A carrying box is good for keeping everything in and also ideal for outdoor work – you can sit with it on your knees with the painting board held in the lid.

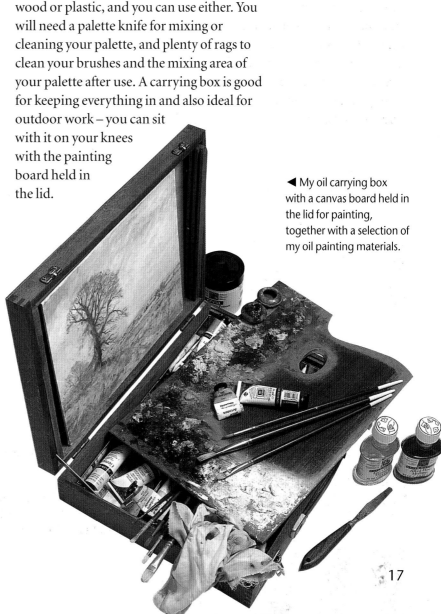

◀ My oil carrying box with a canvas board held in the lid for painting, together with a selection of my oil painting materials.

17

Colour Mixing in Oil

Naturally, most of the principles for mixing colours with oil paint are the same as for watercolour. If you haven't read the chapter on mixing colours in watercolour on page 12, please read it now before you continue with this chapter.

Important differences

The most important difference between the two is the medium itself. When a brush loaded with watercolour paint is dipped into another colour on the palette, the two colours mix together in seconds. Also, it is the amount of water that makes the paint lighter. It is just the opposite with oil.

With oil, when a brush full of paint is added to another colour on the palette, nothing happens. The two paints have to be physically mixed together with the brush to mix the colours. If the paint needs to be made lighter, this is done by adding white paint and mixing instead of diluting with water. Therefore the process of colour mixing is slower with oil than it is with watercolour.

Because of this, I use more colours when working in oil than I do in my watercolour painting. It can help to make a short cut to

Always squeeze your colours onto your palette in the same place. Then you will know where to reach for the right colour every time.

making a colour, also the ready-mixed colour could be cleaner and fresher than the one I would mix with dirty brushes.

Naturally, the three primary colours are still the same, with different reds, yellows and blues. I suggest you start by mixing from the three primaries first and use the colours I have used for the exercises in this book. Then, as you gain experience, gradually add more colours to your palette.

If you are mixing a pale colour, before you put the predominant colour down on your palette you must put white first and then mix in the other colours.

Practise copying colours

Look around at objects in the room and try to copy the colours. Don't mix too much colour, only enough to paint an area of about 7 x 7 cm (3 x 3 in). Remember that a colour changes slightly when it is placed against another colour. For instance, if you were to paint the colour of your curtains onto your white canvas, it could look different to the actual curtain colour. However, if you then painted in the wall colour that the curtain is resting against onto your canvas, you would find that the colour looked more accurate.

Mixing 'black'

I don't use black with my oil paints, for the same reason that I don't use it for watercolour. My 'blacks' are mixed from the three primary colours.

Practise your mixing – you will get a tremendous thrill when you achieve the colours you were trying for. You won't be able to paint a picture, no matter how small, without mixing colours, so you will get better with every painting you do.

► Oil painting colour mixing chart.

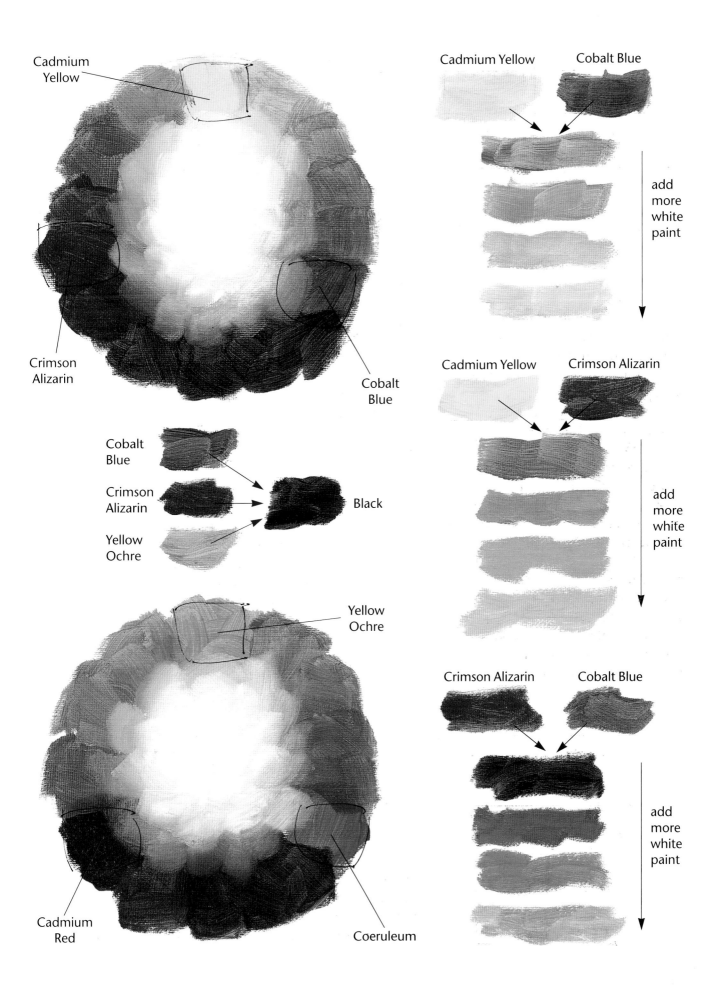

Cadmium Yellow

Crimson Alizarin

Cobalt Blue

Cobalt Blue
Crimson Alizarin
Yellow Ochre
Black

Yellow Ochre

Cadmium Red

Coeruleum

Cadmium Yellow Cobalt Blue

add more white paint

Cadmium Yellow Crimson Alizarin

add more white paint

Crimson Alizarin Cobalt Blue

add more white paint

Oil Techniques

The rules of nature in landscape painting are the same whichever medium you use, but the medium can often dictate which scene you paint. Oil painting is more complicated for working outside than watercolour, because of the equipment needed. But it can be more relaxing, with more time to think and enjoy the subject – and no worrying about a watercolour wash that's running out of control! By the way, I like both mediums equally.

Don't be afraid to change part of an oil painting that has gone wrong. Simply wipe it out with a rag and start again.

Opaque colours

Oil painting is the opposite to watercolour: you work from light to dark in watercolour, but from dark to light in oil painting. You can do this because the colours are opaque and you can paint a light colour over a dark colour and the light colour will 'cover' the dark one up.

To make a colour lighter, you add white paint. Naturally, during a painting you will find the process changes to get particular effects but, in general, work the painting from dark to light. I use Alkyd Medium to help the paint to dry quicker – this is ideal, especially for working outdoors. As I did with watercolour, I have shown you some basic oil techniques on these pages.

A turpsy mix

I usually start my oil paintings by drawing the picture with a No. 6 sable brush, using

▼ A painting can be drawn with a turpsy mix before oil colour is applied.

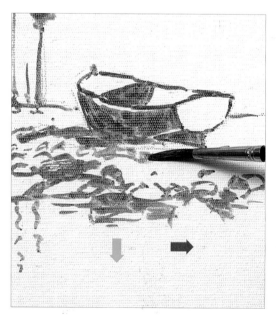

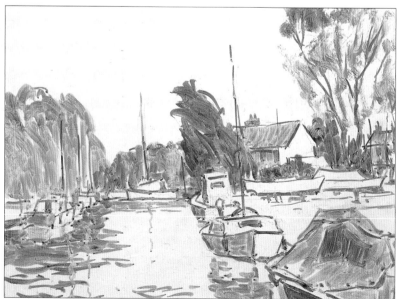

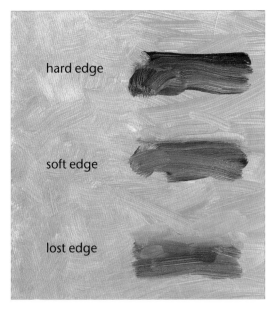

hard edge

soft edge

lost edge

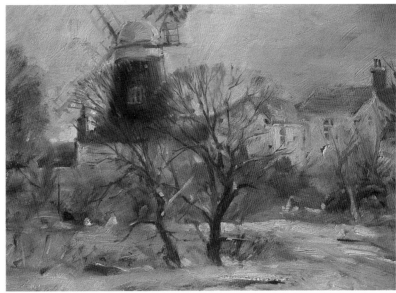

Cobalt Blue and a little Crimson Alizarin mixed with plenty of low odour thinners to make a turpsy mix which can be applied like watercolour.

When I have drawn the picture, I then continue to paint in the dark areas and middle tones with the same turpsy mix, leaving the white canvas as the lightest areas. This gives me the tonal areas and dimension to the painting. When this is dry (this takes about 20 minutes) I start the painting in colour. Always work paint thinly at first and apply it more thickly as you progress through your painting.

Painting edges

This is important. A 'hard edge' makes a shape or part of a shape very clear. A 'soft edge' gives a feeling of softness and distance. A 'lost edge' loses its shape and leaves things to the viewer's imagination.

Thick paint

In most cases, I suggest that you leave your thickest, juiciest paint until last. Doing this can give a wonderful feeling of strength and dimension to a painting.

▲ Look closely at this painting to see all the different edges. With experience, you will learn how to use these edges in your paintings without thinking.

▼ Thick paint gives a three-dimensional look to areas of a painting, making it come to life.

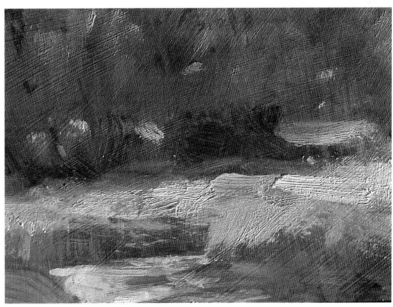

Simple Perspective

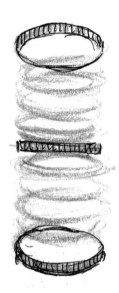

Your next step before you start landscape painting should be to take some time to practise simple perspective. If you think you can't draw, don't let this worry you. Some artists can paint a picture of a scene but would have difficulty in drawing it in pencil. However, although broad masses of colour, shapes and tones can make a wonderful painting, if you want more detail in a picture you will need more drawing ability, and this can only be achieved by practice. Those of you who have not painted before will still be familiar with the terms: horizon, eye level and vanishing point; but now let us see how we use them in drawing.

▲ To help you remember perspective, hold a coin horizontally in front of your eyes (EL) and you will only see a straight line. Move the coin upwards (above your EL) and you will see underneath it. Move the coin down (below your EL) and you will see on top of it.

Finding your eye level

When you look out to sea, the horizon will always be at your eye level, even if you climb a cliff or lie flat on the sand. So the horizon is the eye level (EL). If you are in a room, although there is no horizon, you still have an eye level. To find this, hold your pencil horizontally in front of your eyes at arm's length and your eye level is where the pencil hits the opposite wall. If two parallel lines were marked out on the ground and extended to the horizon, they would come together at what is called the vanishing point (VP). This is why railway lines appear to get closer together and to finally meet in the distance – they have met at the vanishing point. On the opposite page, I have drawn a red line to represent eye level.

I have also drawn a red square and, to make this into a box drawn in perspective, I have put the vanishing point on the right. With a ruler, I then drew lines from the two right-hand corners converging at the VP. This gave me the side of the box. Look at the two blue squares above this. Here, I have done the same, but also drawn lines from the left-hand corners of the square. I then drew a square parallel to the front of the box and kept it within the VP guidelines and this created the other end of the box. I repeated this for the green squares.

Remember, anything above your EL you see underneath it (the blue boxes), anything below the EL you see on top of it (the green boxes). This is very important. Although the boxes are drawn in the same way, by adding some simple pencil shading they have become three-dimensional forms, except for the top blue one with no shading, and that gives the illusion of a transparent box.

Putting clouds in perspective

In the same way, clouds can be drawn in perspective in a very simplified way – see my examples (opposite, top right). Naturally you won't be drawing clouds in quite this way, but seeing what happens with perspective will help you draw clouds with greater understanding.

Don't get too tied down with perspective, nature will help when you are outdoors. Remember, observe and practise.

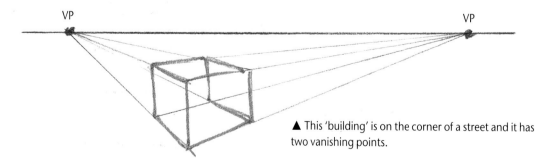

▲ This 'building' is on the corner of a street and it has two vanishing points.

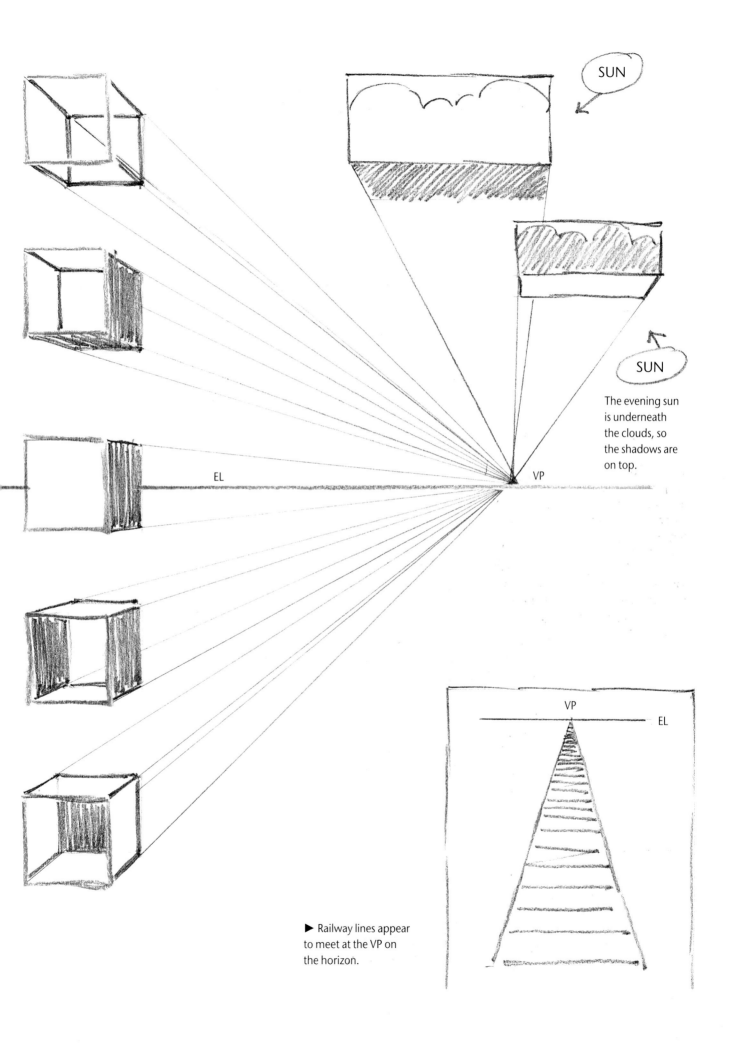

SUN

SUN

The evening sun
is underneath
the clouds, so
the shadows are
on top.

EL

VP

VP

EL

► Railway lines appear
to meet at the VP on
the horizon.

Shape and Form

a

light source

b

This is perhaps one of the most important lessons to learn in this book: how to create the illusion of a 3D object, which actually looks three-dimensional on a flat surface, i.e. your paper. To do this, we use light and shade (light against dark, dark against light).

Look at the examples on this page. In **a**, I have painted a small wash. But it is shapeless and meaningless. In example **b**, I give it a light source and a shape starts to emerge.

In **c**, I have gone one step further and drawn a pencil line around the shape to represent a box. The top is lightest where the light source is strongest. The left side of the box is lighter than the right side, which is in strong shadow and therefore the darkest. So the 'form' of the box is created by light against dark. The top edge of the box is created by the pencil line which is darker than the paper background. The front side is darker than the paper on the left, and lighter against the darkest right-hand side of the box. Therefore, only through light and shade (light against dark, dark against light) has the box shape been created, giving a 3D illusion. Naturally this applies not only to landscape but to everything we paint.

In example **d**, the box is the same as **c**, but on a dark background. The background is darker than the darkest side of the box, therefore it is a light box against dark. But the box in **c** is a dark box against light (a white paper background).

Lost and found edges

When we look at a landscape, our eyes can't see everything with crystal clarity. Some objects have clear hard edges, while others have soft edges, and ones that you can't even make out. We call these 'lost and found' edges. A hard edge always stands out, while a soft edge or lost edge will recede. This helps to give dimension and depth to a painting.

If you look carefully at **e**, the background is the same tone as the darkest side of the box and, therefore, the edge disappears. This is a lost edge, but you can still recognise the shape as a box. This adds a little visual mystery which can be an asset in a painting.

d

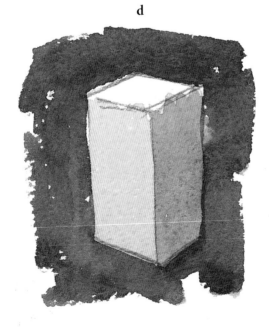

e

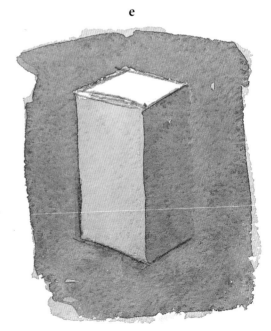

c

Shadows

Shadows are very important for the landscape painter. They show form and shape and can give a large distant landscape a far more interesting and dynamic look, when the shadows (from clouds) are falling on distant fields or mountains and contrasting against the brightness of the sunlit areas. Remember, you only see them because they are dark against light. The foreground is also helped with shadows.

Never be afraid to put shadows in. Be positive – they will always help to create atmosphere and give shape and form to your landscapes.

◀ Here, the snow foreground is left as white paper, but it has no form or dimension.

◀ As soon as a shadow is cast on the snow, it shows the contours of the snow and gives the white paper meaning. In this case, the shadow gives the impression of the snow being flat.

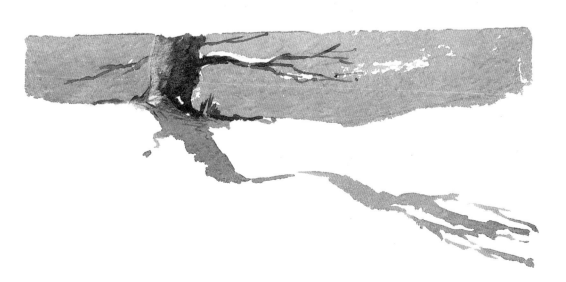

◀ A shadow can transform the snow from flat to uneven, and this is achieved without painting any other tonal effects in the snow. Usually the stronger the sun, the darker the shadow.

Painting Skies

We are now ready – if you have practised mixing colours – to try some simple exercises. These are to be treated in broad terms; don't try to put much detail into them. Copying them will make you more familiar with the subject when you paint out-of-doors.

Gaining in confidence

I can't stress too much the importance of being familiar with your brushes, paints, colour mixing and, finally, your subject matter. The more you know about all these, the more confidence you will have – and the better your paintings will be.

I have taken the four main ingredients of landscape – sky, trees, water, and ground – for the purpose of some simple exercises, starting here with the sky. Some of these exercises were done in watercolour and some in oil, but the general teaching applies to each subject. If I have worked an exercise in watercolour, do have a go with oil. Remember that the object of these lessons is to practise and to learn.

So, let us consider the sky. Whatever type of landscape you paint, the sky – to my mind – plays the most important role. It is the sky that conveys to us the type of day it is, whether it is sunny, cold, blustery, rainy, etc. Even from indoors, one look at the sky can usually indicate what it is like outside.

The sky is the all-embracing mood in which the landscape sits. If this mood is captured, it will follow naturally through to the rest of the painting. As I said earlier, our senses help us to keep the mood of a painting alive. If you paint a sky with feeling and atmosphere, you can go on to paint a masterpiece. If your sky hasn't got atmosphere or feeling, that landscape can never become your best work.

▼ I painted this sky with my No. 10 sable brush on Bockingford watercolour paper 200 lb Not, measuring 17 x 33 cm (7 x13 in). It makes three important points. Firstly, I have used strong perspective for the clouds. This gives distance. Secondly, I have only used one wash of different colours, wet-on-wet. This simplifies the sky. Finally, when this was dry, I painted a suggestion of landscape to give scale.

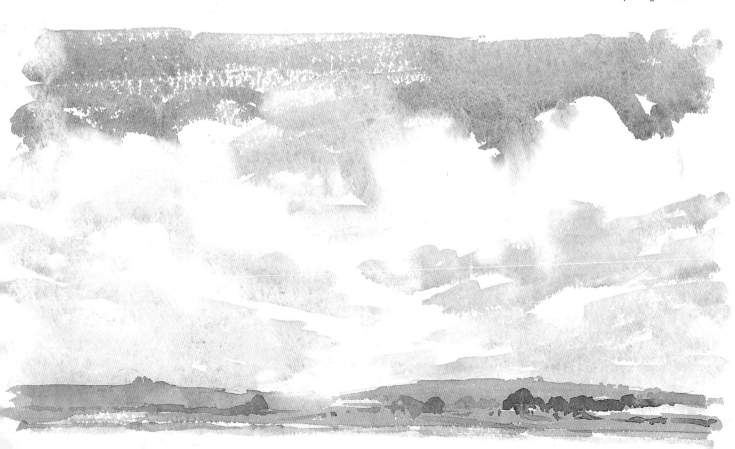

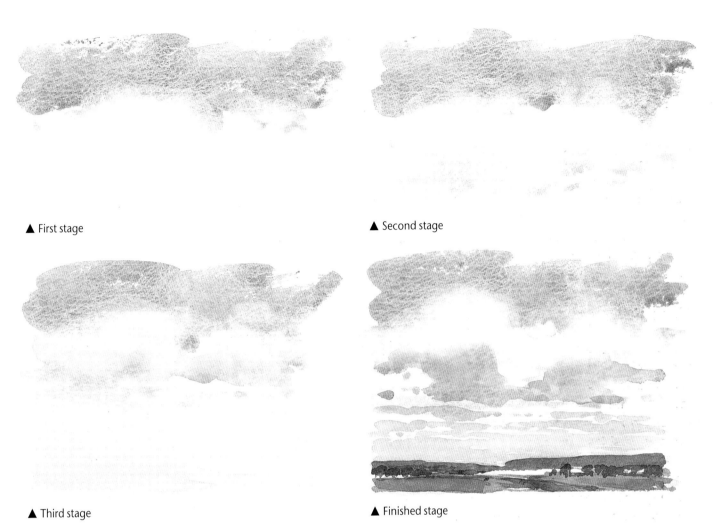

▲ First stage

▲ Second stage

▲ Third stage

▲ Finished stage

Paint a simple sky

For this exercise, I used Bockingford watercolour paper 200 lb Not, and painted it twice the size it is reproduced here. Be warned, you can't copy mine exactly. It's impossible – I couldn't! So if your paint runs a different way to mine and it looks good, keep it. That is watercolour! Relax and enjoy it.

First stage
Using your No. 10 brush, paint the blue sky with French Ultramarine. While it is still wet, paint some water up into the blue to create soft edges.

Second stage
Now mix Yellow Ochre and Crimson Alizarin and paint it into the wet areas, letting the paint mix. Finally, paint in some horizontal brush strokes of paler (add water) French Ultramarine under the clouds.

Third stage
While this is wet, paint into it a mix of Crimson Alizarin and Yellow Ochre and paint down to the horizon. Then continue but add more Yellow Ochre and paint to the bottom of the picture.

Finished stage
The first three stages were all done while the paint was wet. Now let it dry. Then start by wetting the undersides of the clouds and painting dark shadows underneath them. (Use the colours you have been using, but darker.) By starting with water, this softens the edges. Continue with horizontal brush strokes to represent distant clouds. When this is dry, paint in the distant landscape.

▲ First stage

Moving clouds

When you feel you are ready to paint skies out-of-doors from nature, you will find it very confusing because the clouds will not stop for you! Naturally some clouds (those in the distance) appear to move much more slowly than those immediately above us, allowing us to take more time to paint them. But we must accept the fact that the sky moves and we have to paint it while it is moving.

Start by doing pencil sketches – the three types of sketch: enjoyment, information and atmosphere. Keep a sketchbook reserved just for skies because this will become an important source of reference for you. As well as your 2B or 3B pencil, remember your kneadable putty rubber for rubbing out highlights of clouds.

The secret of drawing moving clouds is to look at the sky and watch the pattern of movement. Observe which banks of clouds are going behind others, which are moving

Don't practise on expensive paper – not wanting to spoil it will restrict your freedom and your painting progress will suffer.

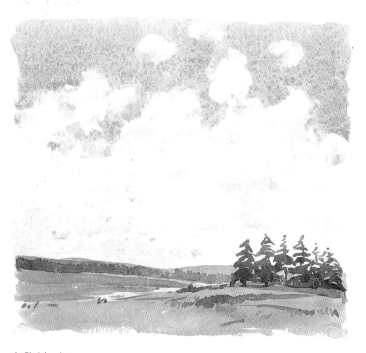

▲ Finished stage

Lifting out clouds

For the sky exercise above, I used Bockingford watercolour paper 200 lb Not, measuring 17 x 20 cm (7 x 8 in).

First stage
Start by painting the 'blue' sky, using a mix of French Ultramarine and a little Crimson

Alizarin. Then water this mix down and add Yellow Ochre and paint the cloud area. This must be very wet.

Finished stage
Now, using a crumpled tissue, gently blot the blue sky and cloud area to represent clouds. When this is completely dry, add the shadows and paint in the landscape.

fastest, and so on. Here's a good tip. Screw your eyes up (squint) and you will see the mass of shapes in a more simplified pattern. This method of simplifying, which you can use for every subject, should become second nature. When you do this, apart from simplifying shapes, the middle tones disappear and the darks and lights are exaggerated. Practise this – it is as important to you in all your painting as mixing the correct colour.

When you have got the 'feel' of the sky and its movements, wait for a descriptive formation to unfold – look hard at it, hold your breath and off you go!

Start in the middle of the paper, as this will give you room to manoeuvre in any direction, and roughly draw the shapes of the clouds. Then, very broadly, shade in the areas of tone. Depending on the speed of the clouds and your speed, the formation you started with may have changed but, because you have observed the nature of cloud movement you should be capable of a little 'ad libbing'.

Don't try to change it!

Once you have decided upon your sky formation and started, don't try to alter what you have done to look like the changed sky – it will change again and you will be left 'up in the clouds'! If you have to change because the sky has developed into an absolute beauty, then start again on another page. Don't do these sky studies any larger than 20 x 28 cm (8 x 11 in) but you can sketch them as small as 12.5 x 10 cm (5 x 4 in).

When you have gained enough confidence working in pencil, have a go with colour. Incidentally, on all your outdoor sketches, especially skies, make a note of the time of day, position of the sun, type of day and the date. This information will help you to understand the sketch totally at a later date.

One last point. When you paint a sky, add some part of the landscape, even if it is only a line of distant hills. This relates the sky to the ground and gives scale, depth and dimension.

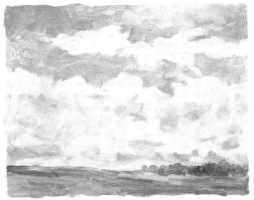

◄ This sky, in oil on fine grain oil sketching paper, 15 x 20 cm (6 x 8 in), gives the illusion of a bright, sunny day with soft, feathery clouds being blown across the sky. The area of bright green against the dark trees, and the pink in the clouds helps to create a sunlit effect.

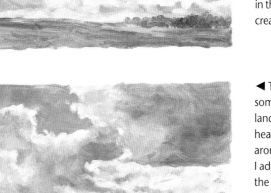
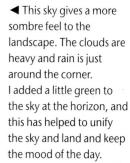

◄ This sky gives a more sombre feel to the landscape. The clouds are heavy and rain is just around the corner. I added a little green to the sky at the horizon, and this has helped to unify the sky and land and keep the mood of the day.

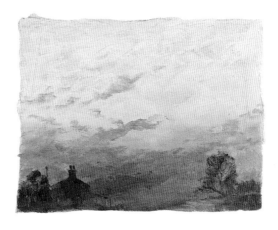

◄ This painting and the one below were painted on primed Waterford watercolour paper 200lb Rough, then given a wash of Acrylic Raw Sienna and Crimson Alizarin. A strong sunset can be very powerful in a painting, but don't overdo it. Understate that breathtaking redness, or it will look unrealistic.

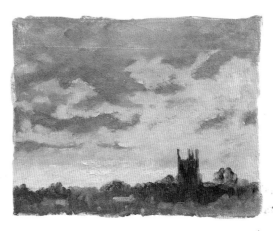

◄ This sky is in total contrast to the one above. The early morning sun is starting to warm the distant sky, the night clouds are drifting away and you can feel the promise of a nice day. Notice how some of the 'red' background wash shows through in places, adding life and interest to this sunrise.

Painting Trees

The tree is nature's best gift to the landscape artist when it comes to the composition of a painting. For instance, one lone tree can make a picture. Trees can be used to break the horizon line; they can be positioned to stop the eye going forward or to lead the eye into a picture. Go out on sketching trips and just sketch trees; in fact, keep a small sketchbook for trees, as I suggested you do for skies.

First things first – winter trees

Before you start painting trees, learn to draw them first. If it is the right time of year, find a good-looking tree out of leaf, and make an information sketch of it. Look at the overall shape of the tree to get its character. Draw it as carefully and with as much detail as you can.

The more you work at that sketch, trying to draw every branch, the more you are learning about the tree's form, growth pattern, size, and so on. After you put down your pencil (your fingers and wrist still aching), you will realise just how much you have learned about that one tree. Then use a sable brush and just one colour and do the same exercise with brushwork.

Don't ever worry about the mistakes you make – this is all part of the learning process.

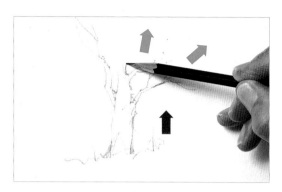

◀ When you draw your trees, always start at the bottom and draw upwards in the direction the trunk and branches grow.

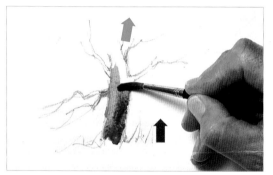

◀ To show sunlight on the trunk, paint a light colour first and, before this dries, add a dark colour. They will merge – wet-on-wet.

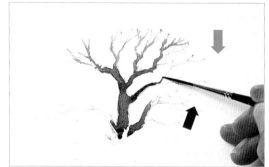

◀ Use your rigger brush to paint the thin branches. Just as you do when drawing with your pencil, work the brush in the direction the branch is growing or going.

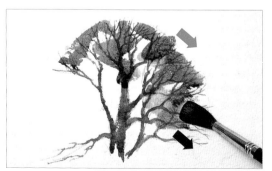

◀ For the feathery branches, use a large brush. Push the brush 'flat' on the paper and move it up and around. Don't worry, you will not hurt the brush!

30

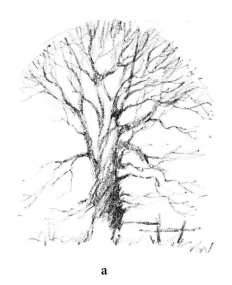

a

Paint a tree in watercolour

In figure **a** (left), I have drawn a tree with my 2B pencil. In **b, c** and **d**, I have painted it as a winter tree using my No. 6 sable brush and my rigger. Finally, using the same pencil drawing and the same brushes, I have painted the tree in leaf (**e, f** and **g**). Practise this exercise – it will give you confidence when you work outdoors. Trees are a very important part of a landscape. If you can, take some photographs of different trees in winter and summer. Use these for reference and copy them for practice. The close-up photographs on the previous page show how particular areas were worked.

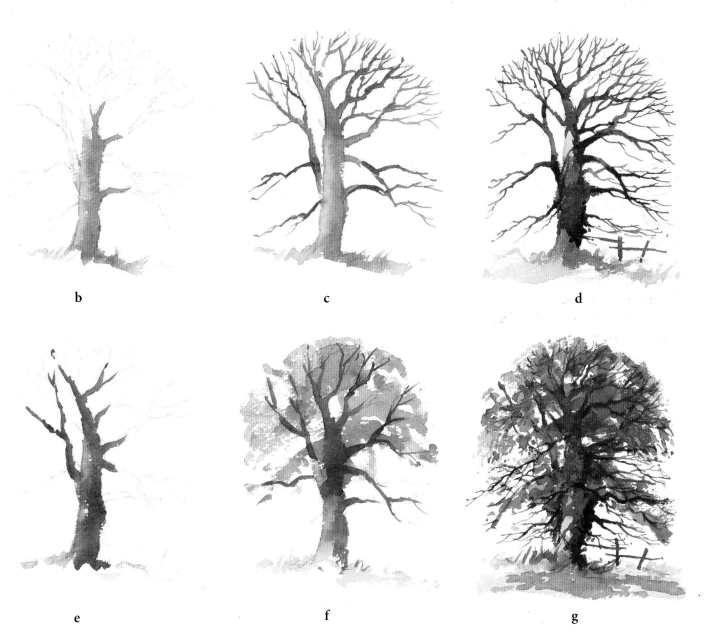

b

c

d

e

f

g

Start sketching trees in leaf

When the leaves come out on the trees, go out and sketch them, again using pencil first.

Work your first sketch of a tree in leaf from a distance of about 275 m (300 yd) From this distance, you will see only the broad shape and character of the tree and you won't be tempted to worry about the detail – you won't see it from that distance! Then sketch from closer positions until you are near enough to make separate studies of areas of branches and leaves in the tree. When you get very close and look into the tree, you will have to screw up your eyes to pick out the shapes you have to draw.

Never make a tree in leaf look like a solid lump of Plasticine! Even if it is a mass of leaves, like a large chestnut can be, there will still be light and shade in the pattern of foliage and in most cases sky will show through in places. Use the 'half-closed eyes' technique to its full advantage and pick out the different tones and shapes of the leaf masses. Shade them in with a 3B pencil and make particular note of the leaves that show dark or light against the sky. These areas give it sparkle and help to identify the species.

Painting leaves

When you feel you are ready to work in paint, work very broadly to start with, looking for the large mass areas of leaves first, then break those areas down into smaller areas of shape, colour and tone. Start again from about 275 m (300 yd) and work closer as you gain confidence. Don't put too much detail into trees in the middle distance or you will find them jumping out of your picture. Whether you are using pencil or brush, always draw the tree branches in the direction in which the tree is growing. This will help to create a sense of growth and reality.

When you start to draw a tree, start at the base of the trunk and work upwards as though the tree were growing from your pencil or brush. Where the tree is mostly foliage, let the brush strokes follow the direction of the 'fall'

of the leaves. It is often tempting to go on a little too long with a bigger brush because you are in the swing of things but don't. When the brush gets too big for smaller branches or leaves, change to a smaller brush.

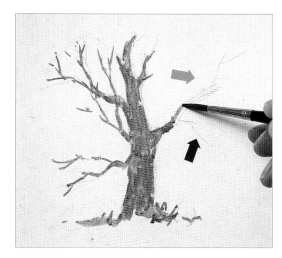

◄ Try these exercises using oil paint. Start with a turpsy wash and paint the tree from the base upwards. Painting things the way they grow makes them look more natural.

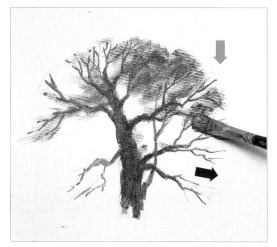

◄ For the feathery branches, load a Bristlewhite brush with a small amount of paint and drag it round and in an outward direction over the dry, already-painted branches.

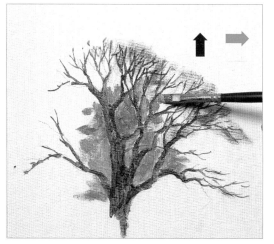

◄ A common technique is to use a small brush to paint in sky colour between some of the larger branches.

► Copy these examples of trees. They will help to give you more confidence when you go outdoors to work. The top four were painted in watercolour on Bockingford watercolour paper 200 lb Not. The two oils below these were painted on primed Waterford watercolour paper 200 lb Rough. All are reproduced half the size they were painted.

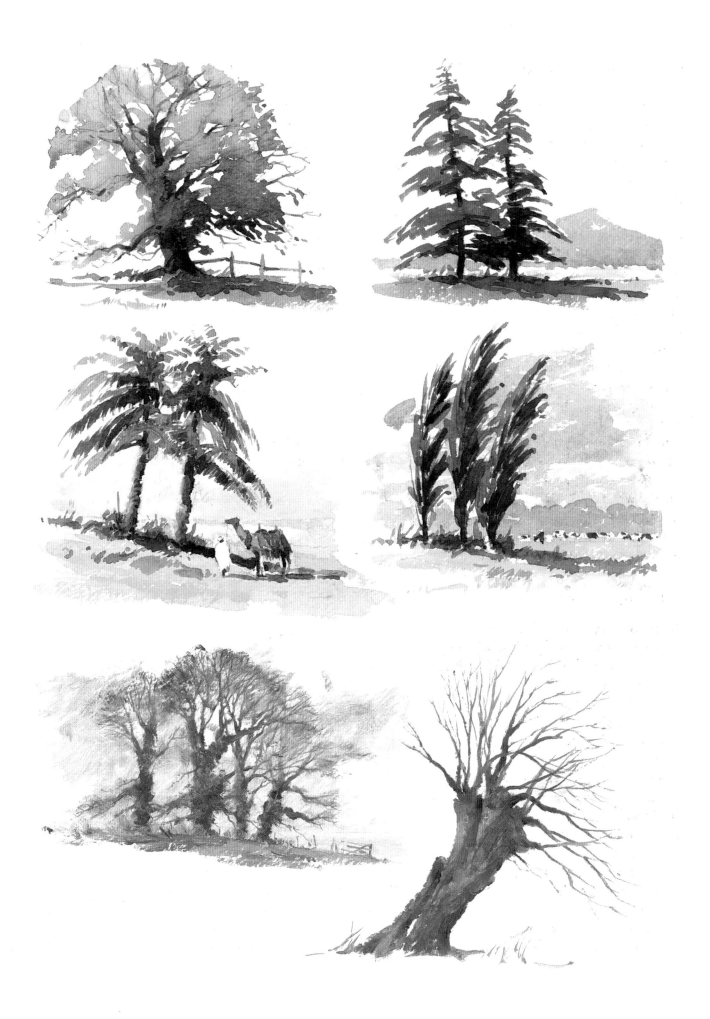

Painting Water

Water is a very exciting subject to paint. It has so many moods and, like the sky, it is always changing. I have always been fascinated with water. I am a keen angler and I have observed water in its many moods, from sunrise to sunset – misty, clear and muddy – and I still get excited about painting it.

Never overwork it

When painting water, there are certain rules that must be observed and the most important of all is that all movement lines or shapes must appear perfectly horizontal on the canvas or paper, otherwise you will find that you have created a sloping river or lake in your painting! Another important rule to remember is not to overwork the water, especially in watercolour.

Upon reflection...

Finally, painting a reflection in water will always give the illusion of water to the onlooker. The three simple paintings on the right illustrate the use of reflections.

Sometimes you will find that the reflection of the sky is all you will see in water, especially in small areas, such as puddles of water or an area of water that is completely covered by one solid reflection without any distinguishing shapes. However, if you painted 'unreflected' water it might not be convincing. When nature lets you down, use your 'artistic licence' and put a reflection in! This could be anything from a broken branch, a fence post, a clump of grass, or even an exaggerated cloud formation. Although nature is a wonderful master, there are times when an artist needs to give it a little extra help on paper or canvas.

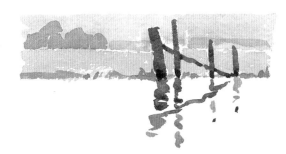

◄ By painting in simple reflections of the posts, white unpainted paper becomes water.

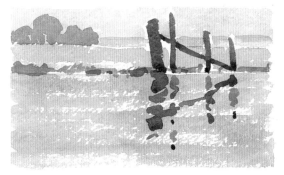

◄ Here I painted a simple wash for the water, finishing with a dry brush technique. When this was dry, I added the reflections.

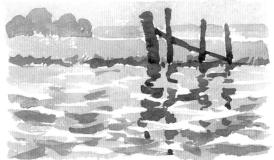

◄ More movement in the water can be achieved by working short horizontal brush strokes of varying tones. Notice that the reflections were painted in the same way. I used the same colours for the reflections as the posts.

Simplifying water on location

The three paintings shown on the opposite page are all good examples of how you can simplify your water. These were done on location where usually there isn't time to paint 'complicated' water. But even if you have lots of time, try to keep things reasonably simple.

▶ From Parknasilla, Ireland
watercolour on cartridge paper
20 x 28 cm (8 x11 in)
Of the three paintings on this page, this one is the simplest. I painted the water in one wash, changing the colour slightly as I worked down the paper.

◀ The Windmill at Hickling
watercolour on cartridge paper
20 x 28 cm (11 x16 in)
This painting was done looking towards my house. I left the puddles of the ploughed field as unpainted white paper when I painted the field, then added colour. The reflection of the telegraph pole helps give the illusion of water.

▼ The Grand Canal, Venice
watercolour on cartridge paper
20 x 28 cm (8 x 11 in)
I achieved the choppy water of the canal by working the first wash in short horizontal brush strokes, leaving white paper showing in places. When this was dry, I painted small brush strokes, then larger ones towards the base of the paper to show perspective. I didn't put in reflections – there weren't any and I decided none were needed!

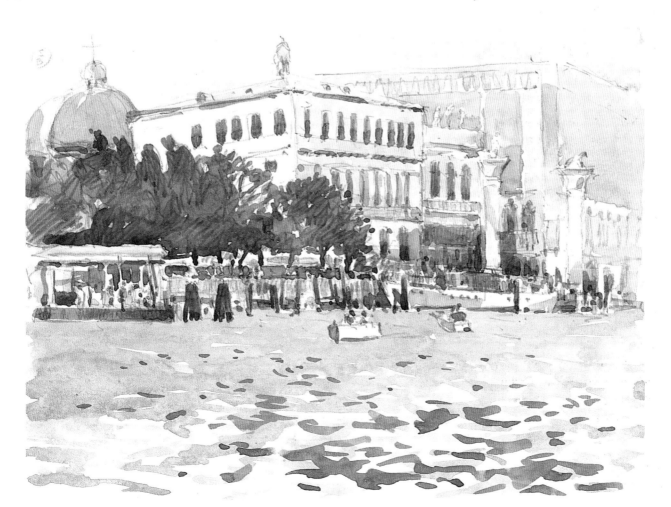

The colour of water

The biggest worry for most students when painting water is its colour. As with trees, the secret is observation and then simplification of the shapes and tones. The colour of water is dependent on its surroundings; the objects it reflects – sky, trees or buildings – will show their shape and colour in it and so determine the colour of the water. Light colours are slightly darker when reflected than the real thing, while darker colours are slightly lighter.

As with the sky and trees, start by sketching in pencil. Find some still water with good reflections, sit down and look at the water and its surroundings, half-close your eyes and see the shapes and tones of the reflections. When you're confident that you've simplified the shapes in your mind, do a sketch in 3B pencil.

Movement of water

Painting moving water with reflections is a little more difficult. Like the sky, it won't keep still. Observe the water and its surroundings and try to look in one place, i.e. don't let the flow of the water take your eyes with it. If you can do this, you will then be able to make out the shapes and colours of the reflections.

Although water may move, reflections from the land stay still. The water's movement breaks up the shapes of the reflections, giving them strange shapes, but with half-closed eyes you should be able to sort out the major shapes and forms. Don't fall into the trap of painting horizontal lines all over your water. This can make it look artificial and contrived. Keep horizontal lines for definite effects of water movement or reflected light.

Painting still water

This oil painting on a Daler board measures 15 x 23 cm (6 x 9 in). I pre-painted the surface with an acrylic wash of Raw Sienna and Crimson Alizarin.

First stage

Draw the picture with your No. 6 sable brush and paint in the tones with a turpsy wash of Cobalt Blue and Crimson Alizarin. Notice how the acrylic ground colour shows through, helping to give the atmosphere. Now paint in the sky using Titanium White and Cadmium Yellow with your No. 4 Bristlewhite brush.

Finished stage

Paint in the distant trees with Titanium White, Cobalt Blue and Crimson Alizarin. Add Yellow Ochre to the mix and paint the dark hedge and its reflection. Paint over the trees, adding their reflections. Work the green bank using Cadmium Green, Cobalt Blue, Crimson Alizarin and Titanium White. Paint in the river with a Titanium White and Cadmium Yellow mix. Add a little Cobalt Blue and Crimson Alizarin to darken the tree reflection. Finally, paint in the highlights on the water.

▲ First stage

▼ Finished stage

▲ First stage ▼ Second stage

Painting moving water

I painted this exercise on oil sketching paper, coarse grain measuring 17 x 17 cm (7 x 7 in).

First stage

With your No. 6 sable brush and a turpsy mix of Cobalt Blue and Crimson Alizarin, paint the important features. Leave the water unpainted.

Second stage

With a mix of Titanium White, Cobalt Blue and Crimson Alizarin and your D48 No. 4 brush, paint the sky. Add Yellow Ochre and paint the distant hills. Add more Cobalt Blue and paint the headland. Use the sky colours to paint in the sea. With the same colours, but less Titanium White, paint the posts and yacht. Use more Yellow Ochre to paint in the mud foreground.

Finished stage

Paint in more sea and then using Titanium White and Cadmium Yellow, add the highlights to the water. Now paint over the reflections of the posts using your D48 No. 2 brush. Add highlights to the mud and use a little Cadmium Green with your colours. Finally, decide if you want a white sail or red one. I decided on red and used Cadmium Red and Crimson Alizarin. I used my No. 2 Bristlewhite brush for any small work.

▼ Finished stage

Never overwork water. In watercolour, paper can be left unpainted to represent water. With oil, only use thick paint for movement or for highlighting water.

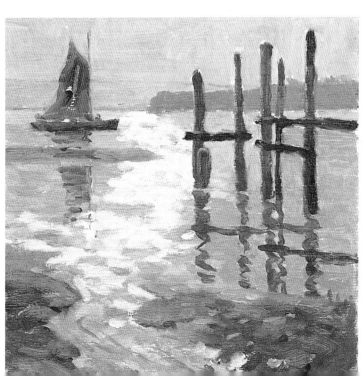

Painting Foreground

The 'ground' in a landscape is very important as it usually represents the nearest part of the landscape. This means that, in most cases, it will have to show the most detail. The detail can be slight, depending on the subject or the style of painting, but often it will have to represent a true and detailed account of itself. This brings me back to observation! By observing, you will become your own teacher and, with practice, paint happily for the rest of your life!

Meanwhile, let's get back to your sketchbook and 2B pencil. Go out into the countryside or in your own garden and sit, look and observe. This is where the information sketch is really necessary. You must draw to learn what happens to things – how a fence goes into the ground; how a cart track is formed; how grass grows; how wild flowers grow, and so on. If your drawing isn't that good at the moment, then try painting directly what you see, to create the same effect.

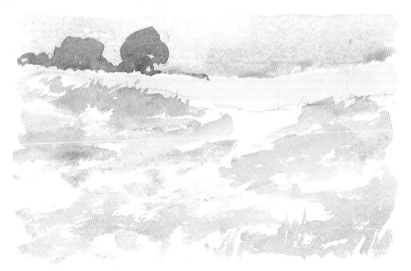

▲ First stage

Using the dry brush technique

This is a very exciting way to paint a foreground. I worked this exercise on Bockingford watercolour paper 200 lb Rough, measuring 12.5 x 20 cm (5 x 8 in).

First stage
Using your No. 10 sable brush and a mix of Crimson Alizarin, Yellow Ochre, French Ultramarine and Hooker's Green Dark, drag your brush over the paper in a dry brush technique, changing the colour as you go. You will be left with a foreground of happy accidents, but under control!

Finished stage
Look for shapes left by the first wash, refine them if you want, and add shadows to them. Add more colour in places and make more shapes. This process can go on as long as you are not overworking the foreground. Finally, put a shadow over the immediate foreground – this could come from any object out of the picture. If you were outside painting, your original wash would take note of the real live foreground you were copying. Here, the sun is on the left, therefore the shadows are cast on the right of objects.

▼ Finished stage

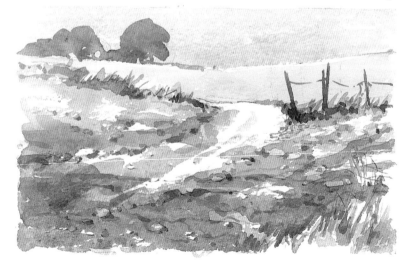

Underpainting with acrylics

When painting with oil, try underpainting with acrylic colours first. The advantage is that they dry quickly and the oil paint will not pull them up when you paint. The acrylic colours I used were Raw Sienna, Raw Umber, Bright Green, and Crimson. The surface was canvas panel, 15 x 23 cm (6 x 9 in).

First stage

Draw the main flowers in simply with a No. 6 sable brush. With a mix of Raw Umber and Titanium White and a No. 4 Bristlewhite brush, paint the left side of the background, changing to Cobalt Blue and Titanium White as you work to the right. Paint in the poppies with Cadmium Red and a little Cadmium Yellow.

Finished stage

Work more colour into the poppies, using Cadmium Red, Cadmium Yellow, Crimson Alizarin and a touch of Titanium White. Use a No. 2 Bristlewhite brush. Then paint in the green background around them using Cadmium Green, Cadmium Yellow and a little Titanium White. Paint in the dark leaves and then the small white and mauve flowers. All this can be done with a No. 2 Bristlewhite brush or a No. 6 sable. As I have said earlier, it is impossible to copy my paintings exactly, even I couldn't do that. But have a go at this one – you will enjoy doing it.

Remember, cool colours (i.e. blues) recede in a painting, while warm colours (i.e. reds) come forward.

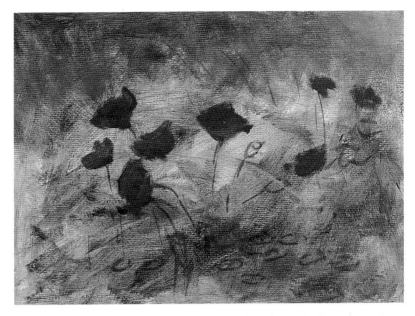

▲ First stage

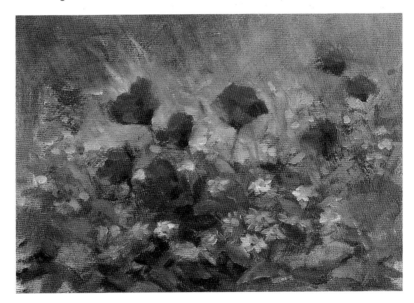

▲ Finished stage

◄ Close-up detail, reproduced actual size.

Trees in the foreground

First stage

I used Bockingford paper 200 lb Not for this watercolour exercise. It is painted with much more freedom than *Misty Morning*, opposite. Start by painting the sky with your No. 10 sable brush using a mix of French Ultramarine and Crimson Alizarin. While it is wet, add Cadmium Yellow Pale and, as you work down, add more Crimson Alizarin. Now let this dry.

Second stage

Use your No. 6 sable brush and paint in the large tree trunk. For this, mix Hooker's Green Dark, Crimson Alizarin and a little Yellow Ochre. Start with a watery mix on the left of the trunk for sunlight. Then with Yellow Ochre and Crimson Alizarin paint in the tree to the right of it. Finally, with the same colours as the large tree, with a little more Yellow Ochre, paint in the tree on the far right.

Third stage

Paint in the hedge and the ground with watery paint, but paint it using free upward, curving brush strokes. Let these 'hit-and-miss' as you did with the foreground on page 38. When it is dry, suggest some leaves and bracken. Use Yellow Ochre and Crimson Alizarin for the bracken colour. Keep your brush strokes loose and free – don't try to get individual detail.

Finished stage

For this stage, use your No. 6 sable and your rigger brush. Paint in the shadow side of the large tree and put shadows on the smaller trees. Now add more branches. Then suggest small branches, leaves, bracken and brambles in the hedgerow with your rigger brush. Finally, use your No. 6 sable brush and paint in the cast shadow on the ground. Observe the way trees come out of the ground. The trunk is usually hidden with other growth, except for trees in park-like conditions.

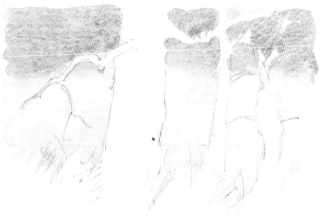

▲ First stage

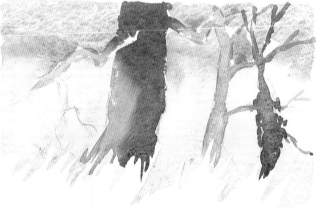

▲ Second stage

▼ Third stage

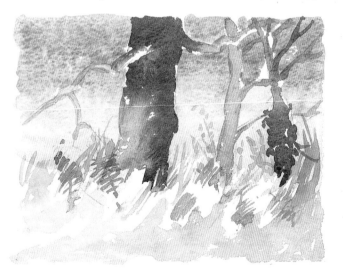

▼ Finished stage

◀ **Misty Morning**
Bockingford paper
200 lb Not
38 x 50 cm (15 x 20 in)
Notice how the foreground is in keeping with the mood of the painting. It has been done softly, using muted colours. Just because you can see detail to put into the foreground of a painting, don't overdo it. In fact, in this picture, the sun and trees are the centre of interest, not the foreground.

▼ Close-up detail of the foreground.

Painting close-up detail

A word of warning about painting close-up detail. If you are painting a tree in leaf on a canvas, say 25 x 20 cm (10 x 8 in), the leaves, to be in scale, would have to be smaller than a full stop on this page. You would paint that tree by defining groups of leaves as detail, not each single leaf. Scale is very important.

When you are out sketching, always make sure you put something in your picture that denotes scale. If there is nothing definite around, then sketch your stool, your hat, or a dog in the picture. This only needs to be done simply, but it will give scale to your sketch and I can't stress enough how important that is.

Things that grow

When you are working on the foreground and you are painting grass, bracken and other things that grow, work your brush strokes in the same direction as their growth and movement. Every brush stroke conveys a story, and you should take advantage of this, especially in close-up work.

Snow can be tremendous fun to paint but it can present problems for sketching and working outdoors. However, if you can get the car out on the road, you can always work from its relative comfort or, alternatively, at home from a window. The stillness and silence of a snowy landscape can be unbelievable. The clear rivers of spring and summer turn to brown, and trees stand out in sharp silhouette.

Capturing snow

A pencil sketch of a snow landscape can be extremely rewarding, with white paper showing through to suggest snow and with areas of dark pencil tone to suggest trees and hedgerows.

Beware when you are painting snow with oil paint – in general, don't use white paint for any of it. Snow is only white in its purest, just-fallen form and, even then, it reflects light and colour from its surroundings. Even the whitest snow should have some colour. Add a little blue to cool white oil paint or a little red or yellow to warm it up.

Never be afraid to make snow dark in shadow areas. It can be as dark, in comparison to its surroundings, as a shadow in a non-snow landscape. Paint snow in a low key: if you take your darkest shadow as number ten and your brightest snow as number one, with a natural gradation of tone in between, you should paint your snow in the range from eight to three. This will leave enough reserve up your sleeve to add darker shadows and brighter highlights.

Pencil Sketching Outdoors

I have said quite a lot so far about sketching and in particular sketching in pencil. You will be familiar with my definitions of sketches from an earlier section. On these pages I have shown three: one information sketch and two enjoyment sketches.

Basic rules

Some very basic rules of common sense apply when you work outside. If you go out sketching or painting, take enough clothing. It can always be taken off, but if you haven't got it you can't put it on – and, if you are not reasonably comfortable or warm, you will not produce your best work. Keep your sketchbook in a polythene bag. I have always done this since I dropped mine in a puddle! You will need two pencils, a knife to sharpen them with (incidentally, always sharpen them before you go out), a putty eraser and your sketchbook. I suggest you use a 2B and a 3B pencil for sketching. The 3B is softer and ideal for shading areas quickly. However, I find I use a 2B pencil for most of my sketching.

Don't go round every corner

When you see a spot for sketching, don't be tempted to walk around the next corner to see if the view is better. When you get there, you could be tempted to go around the next corner, and so on. You will end up coming back to the same spot – an hour later – or carrying on around the next corner and ending up sketching nothing! I've fallen into this trap on quite a few occasions and it is very frustrating, especially if you are with your family or sketching friends and they are waiting for you to settle down! So, if something inspires you – sketch it. If you have enough time, you can go around the next corner and do another sketch.

▲ When we were in Greece, I just had to sketch the entrance to the stadium in Olympia (drawn from inside the stadium). This was where the first Olympic Games were held over a millennium ago. I really enjoyed doing this sketch and felt that, for a few moments, I had been a part of history. I did it in my A4 cartridge sketchbook with a 2B pencil. Note how the figures give scale.

◄ I did this information sketch when I was in Japan. I sat down to work, using a 2B pencil and my A4 cartridge sketchbook. When you're sitting down, you have complete control of your pencil, as your hand can rest on the pad which in turn rests on your knees. I took a photograph of the scene for colour reference and any detail that I might need, in case I wanted to do a painting from this sketch at home.

Making a picture finder

It can be very difficult to look at a scene and know exactly where to start and finish your sketch or painting. To help yourself, cut a mask out of paper or thin card with an opening of about 10 x 8 cm (4 x 3 in), or make the mask the same proportion as your sketchbook so your picture will fit nicely on your paper.

Hold the mask up at arm's length, close one eye and move your arm backwards and forwards and from side to side until the scene is sitting happily in the opening. Then make a mental note of the position of your arm, and key points where the scene hits the inside edge of your mask. You will then have the picture designed in front of you (see my example, above right). Draw the positions of the main features and then relax your arm, put the mask away and draw your sketch.

If you forget your mask when you are out, make a square with your hands and look through them.

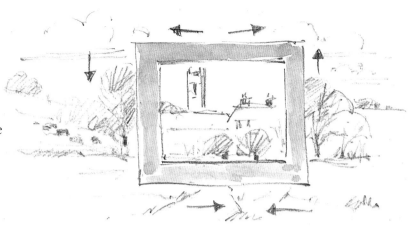

▲ Cut out a mask from card to help you decide what to draw.

▶ I did this sketch while waiting for the TV crew to pack up when we were filming in Seville. I used my A4 sketchbook and 2B pencil. I was stood on the side of the road, hence the freedom of the pencil lines. It took about 6 minutes of hard concentration, but the pleasure it gave me will last for ever. This was a true enjoyment sketch.

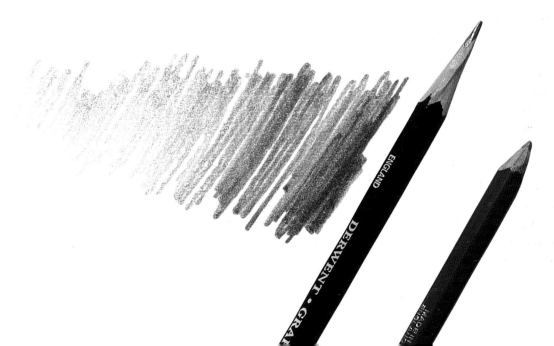

◀ Practise shading on any piece of scrap paper. You must gain complete control of your pencil – it will make your sketches come to life. This tonal shading was done with a 2B pencil. The pencil on the left is the correct way to sharpen your pencil. You can see the point when working and you can get some broad flat strokes for shading. Never sharpen your pencil like the one on the right!

Hickling Church

I have painted my local church on many occasions. I did the sketch, below left, one early spring afternoon. My inspiration was the sun coming out after a heavy shower, bathing the whole scene in light and shadows. However, the wonderful thing about painting from a pencil sketch at home is that you can create any type of weather conditions from your imagination and experience.

▲ *2B pencil sketch on cartridge paper*
20 x 28 cm (8 x 11 in)

First stage

Using my 2B pencil, I started by positioning and drawing the church tower, then drew a line underneath the tower for the end of the two fields. The path and the two large trees were drawn next, and finally the area around the church and the white cottage on the left. Don't try to draw in detail because this can restrict the freedom in your brush strokes as you try to copy your pencil lines. I painted the sky with my No. 10 sable brush, starting at the top with a wash of French Ultramarine and Crimson Alizarin. I then let some Yellow Ochre run into the wet paint, with plenty of

Colours

French Ultramarine

Crimson Alizarin

Yellow Ochre

Cadmium Red

Hooker's Green Dark

Cadmium Yellow Pale

▶ First stage

44

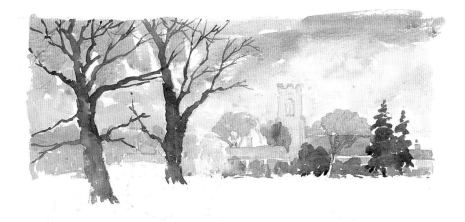

water to give the illusion of sunlit clouds. Notice the small areas of unpainted paper – these help to give light and life to the sky.

Second stage

When the sky was dry, I painted the tower using the Yellow Ochre and my No. 10 sable brush. Then I added some Cadmium Red and painted in the red roofs. Next, adding French Ultramarine, I painted the church roof. I painted the distant trees, working from left to right, with a mix of French Ultramarine, Crimson Alizarin and Yellow Ochre. I added more Yellow Ochre and Hooker's Green Dark to this to paint the bushes and trees in front of the church. Don't worry if some areas mix and blend together because they are wet. This can help to give a more natural look. I painted the two large trees with my No. 6 sable brush and rigger (for the small branches). By now you should be happy with painting trees – if you have been practising! Don't overwork them at this stage.

Third stage

Now, with a mix of Cadmium Yellow Pale and Hooker's Green Dark and my No. 10 sable brush, I painted in the field on the left of the picture. I then mixed French Ultramarine and Crimson Alizarin together

to paint in the puddles. While the puddles were still wet, I mixed a wash of Yellow Ochre and Crimson Alizarin, adding some of the colours already in my palette (greens and blues), and painted the path and the ploughed field. I let the field colour mix with the wet puddle colour in places. It was very important to paint the brush strokes of the path and field in perspective. The unpainted white paper that was 'accidentally' left also helps to make the field look flat.

▼ Third stage

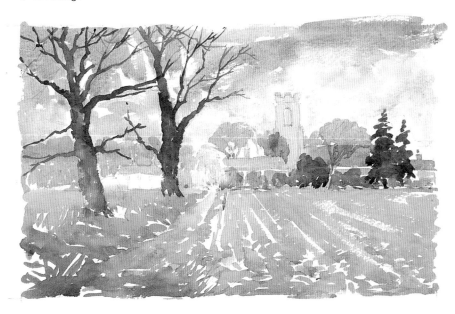

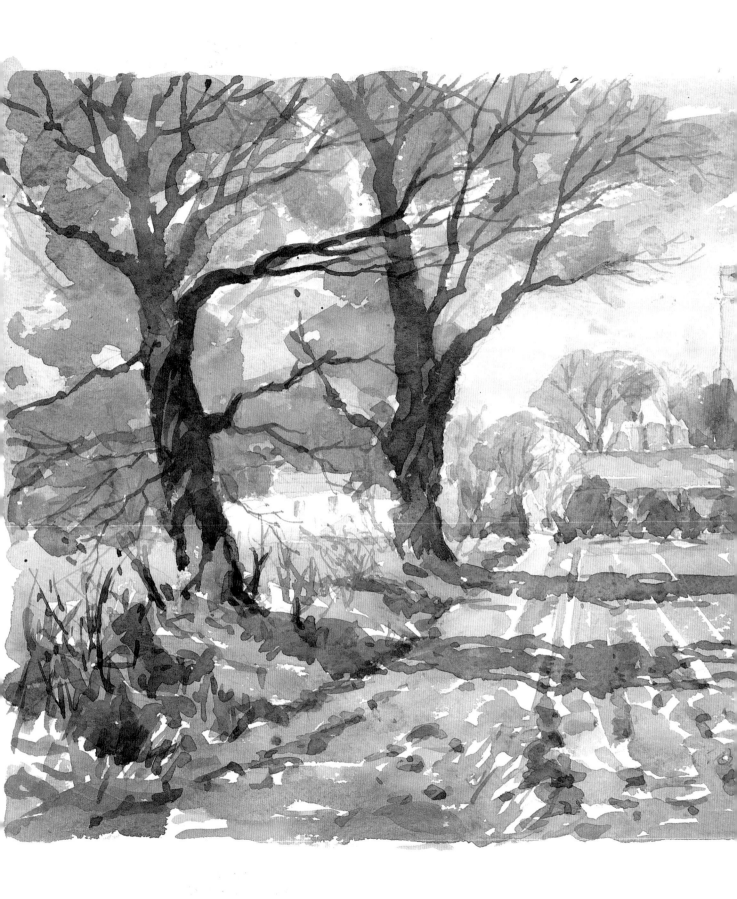

Finished stage

With my No.10 sable brush I put the 'feathery' branches on the two main trees. I used French Ultramarine, Crimson Alizarin and Yellow Ochre. I started at the top and worked down, leaving some light areas on the trunks to represent sunlight – this is important, and don't paint over the white cottage! While this was drying I put in some detail on the church tower, buildings and distant trees with my No. 6 sable and rigger brushes. I added some dark blue to the left of the white cottage to give distance behind the cottage and to define its shape. I then added darker tones and some 'free' detail to the hedge on the left under the trees, with my No. 6 sable and rigger brushes. Then, with a watery mix of French Ultramarine and Crimson Alizarin, I painted in the shadows cast by the two large trees. Notice how they follow the contours of the ground. Finally, I put some shadows on the stones and lumps of earth on the path and field.

▲ Detail from finished stage, reproduced actual size.

◄ **Hickling Church**
watercolour on Bockingford watercolour paper 200 lb Not
25 x 40 cm (10 x 16 in)

47

Sydney Harbour Bridge

When I was in Australia and visiting Sydney, I couldn't resist sketching the Sydney Harbour Bridge in watercolour on cartridge paper from two or three vantage points. For this demonstration, I have worked on cartridge paper in the same way that I do outdoors but, because of the 'perfect' working conditions in my studio, it is a little neater!

First stage

With a painting like this, you have to be confident about your drawing skills, as the most important element of the painting is the bridge. But don't let this put you off – have a go and enjoy it. I drew the water line in with my 2B pencil first and then positioned the bridge, the background buildings, the boat and, finally, the landing stage. I painted the sky with my No. 10 sable brush with a wash of French Ultramarine and Crimson Alizarin. Notice how I left areas of unpainted paper to represent drifting clouds. I used horizontal

brush strokes for the sky, and added more water to make the sky at the horizon lighter.

Second stage

I painted in the distant buildings with my No. 6 sable brush and used a varying mix of French Ultramarine, Crimson Alizarin, Yellow Ochre and a touch of Hooker's Green Dark to suggest trees to the left end of the buildings. I purposely left white areas of unpainted paper to represent sunlight on the buildings and triangle shapes to represent yacht sails. I used Yellow Ochre with a touch of Crimson

Colours

 French Ultramarine

 Crimson Alizarin

 Yellow Ochre

 Hooker's Green Dark

 Cadmium Yellow Pale

 Coeruleum

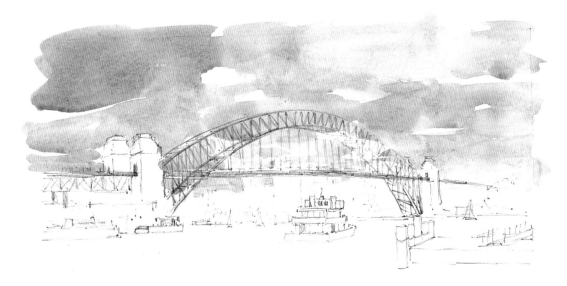

▲ First stage

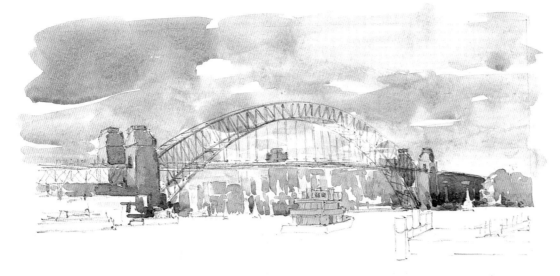

Alizarin to paint the towers of the bridge. When these were dry, I painted on the shadows. Finally, with a Yellow Ochre and a touch of Cadmium Yellow Pale – still using my No. 6 sable brush – I put a wash on the boat.

Finished stage

With the same colours I used for the distant buildings, but darker, I painted shadows on them, being careful to go round the yacht sails. At the same time, I suggested the two boats to the left of the bridge. I painted the water next with my No. 10 sable brush with a wash of Coeruleum and Cadmium Yellow Pale, changing to French Ultramarine and Crimson Alizarin halfway down. Notice how I left white, unpainted paper to represent reflected light. I then painted in the landing stage. I put some darker areas on the shadow side of the boat and painted the reflections and some small brush strokes in the foreground water to give movement. Finally, I carefully went over some of the pencil drawing on the bridge with dark colour using my No. 6 sable brush.

▼ **Sydney Harbour Bridge**
watercolour on cartridge paper
20 x 28 cm (8 x 11 in)

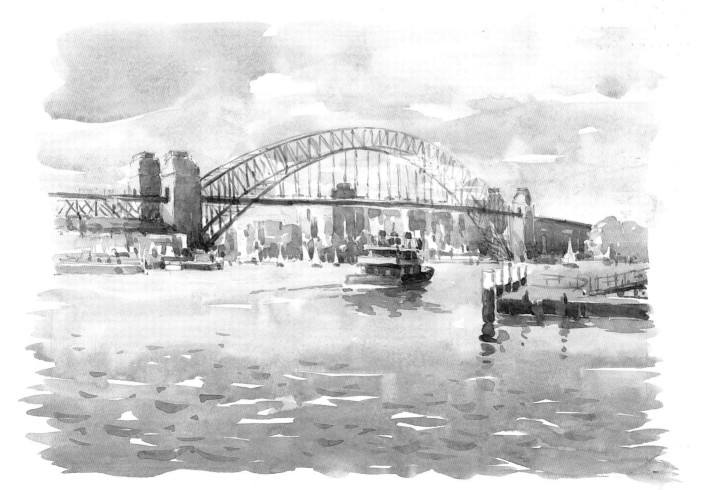

Tuscan Landscape

I have always loved the colours you find in an Italian landscape. In this particular scene, the road runs upwards through sun-baked fields, leading the eye up to the town on the top of the distant hill. When you are out painting, it's amazing how many times nature comes up with the best composition – without the artist having to move mountains!

Colours

Cobalt Blue

Crimson Alizarin

Yellow Ochre

Viridian

Cadmium Green

Titanium White

First stage ▶

First stage

If I had been working on this painting outdoors, I would have probably gone straight in with the paint and not used pencil. But because I was working indoors so that the stages could be photographed, I had more time and I drew in the important features first with my 2B pencil. Then I painted the picture with a turpsy wash of Cobalt Blue and Crimson Alizarin using my No. 6 sable brush. Notice how freely this was done. Remember, when you are using oil paint, adjustments and corrections can be done at most times during a painting.

Second stage

I painted in the sky with my No. 8 Bristlewhite brush and a mix of Titanium White, Cobalt Blue and Crimson Alizarin. I added more Titanium White and Yellow Ochre behind the distant town. I continued down into the distant hills, adding more Cobalt Blue and working my brush strokes diagonally to follow the slope of the hills. A turpsy wash of Yellow Ochre, Crimson Alizarin and a little Cadmium Green over the rest of the landscape gave it an underpainting of warm earth colours and scrubbing the brush harder over the blue drawing lines lifted them, making them less prominent.

◀ Third stage

Third stage
I mixed Cobalt Blue, Crimson Alizarin, Viridian, a little Cadmium Green and a little Titanium White and, using my No. 6 sable brush and No. 2 Bristlewhite brush, started at the top and painted the distant trees and hedges and worked down the canvas, getting darker and making the colour warmer by adding more Crimson Alizarin and Yellow Ochre nearer the bottom of the picture. Then, with the same colours as I had used to apply the turpsy wash over the field in the second stage, but this time adding Titanium White, I painted over the fields once more, but now with thicker paint and using my No. 2 Bristlewhite brush.

Finished stage
I continued down the canvas, adding paint to the fields and making the colours stronger and warmer. I then painted in the shadows on them, letting the brush strokes follow the contour of the fields. Next, I put more work into the houses and the field on the right beneath the house. I painted over the fields in the foreground to give them more life using thick paint and my No. 4 Bristlewhite brush. I then decided to make the foreground shadow a little more mauve and painted over the top of the original one. When you get to this stage, leave the painting for a while, then come back with a fresh eye. You will then see if you need to 'add or subtract' to finish your painting.

▶ **Tuscan Landscape**
oil on primed MDF
40 x 30 cm (16 x 12 in)

Camels in Egypt

I was in Egypt filming for a television series and couldn't leave without sketching and photographing some camels. It was also important to experience the heat and see the heat haze in the distance. Notice how the leading camel rider is a tourist with her small backpack, sitting upright and holding on. I had a ride on one, and take it from me, you do have to hold on – very tightly!

First stage ▶

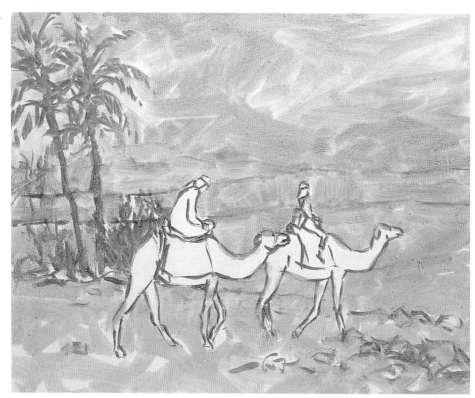

Colours

 Cobalt Blue

 Crimson Alizarin

 Yellow Ochre

 Cadmium Green

 Cadmium Red

 Titanium White

First stage

I drew the scene with pencil first, as I did in my Tuscany painting on page 50. Then I drew in the painting over the pencil with my No. 6 sable brush and a turpsy mix of Cobalt Blue and Crimson Alizarin. Next, with a turpsy mix of Yellow Ochre and Crimson Alizarin, I painted over the whole background with my No. 8 Bristlewhite brush to achieve a warm underpainting.

Second stage

I used my No. 8 Bristlewhite brush with a mix of Titanium White, Cobalt Blue and Crimson Alizarin to paint the sky. I worked the paint thinly to allow the underpainting to show through. I worked the distant sand dunes darker with a little thicker paint. Then I painted in the palm trees and the small bush with my No. 4 Bristlewhite brush and a mix of Cobalt Blue, Crimson Alizarin, Cadmium

Green and Yellow Ochre. Notice how freely I did this. Finally. with a turpsy wash of Yellow Ochre, Crimson Alizarin and a little Cobalt Blue, I painted in the leading camel.

Finished stage

I worked with thicker paint on both camels using my Dalon D77 No. 6 brush, which gave more positive brush strokes than my sable brush. I worked the riders, their saddle blankets and trimmings next with the same brush. I then put in the shadows cast by the camels and the rocks and stones. I then painted over the sand again with thicker paint, using my No. 2 and No. 4 Bristlewhite brushes. I also thinned down the camels' legs, where they had become too thick. Finally, I put some more paint on the rocks and put in the riders' reins with my rigger brush.

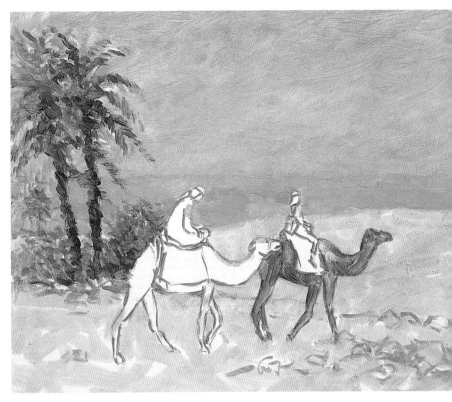

▲ Second stage

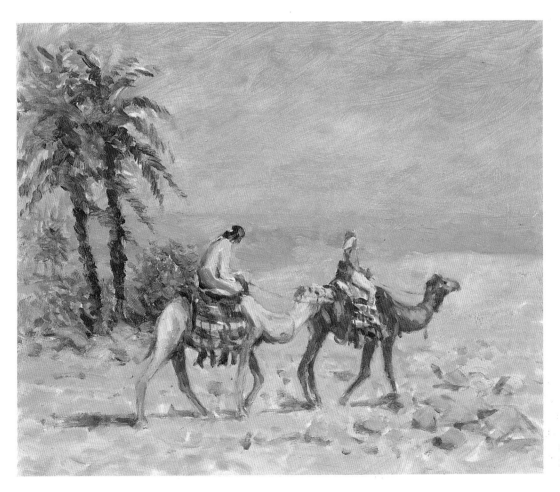

◄ **Camels in Egypt**
oil on primed MDF
25 x 30 cm (10 x 12 in)

Dedham Lock

Dedham is a favourite place for me. The landscape artist John Constable lived and painted in this area. Although he died over two hundred years ago, his work was my main inspiration at art school. In this demonstration, the sun has come out on an early spring day. It's the type of day that gets you excited and makes you feel spring is really here – until, the next day, when clouds cover the sky and it's cold and wintery again!

First stage

To begin with, I drew the scene with my 2B pencil. As with the painting of Hickling Church on page 44, don't try to put too much detail in with your pencil, but make sure the house and lock gates look correct. Position the trees, but leave the small branches undrawn; they can be put in with a brush. I painted the sky with my No. 10 sable brush as usual, using French Ultramarine and Crimson Alizarin, and adding plenty of clouds (Yellow Ochre and Crimson Alizarin) across the sky. This helped to silhouette the trees and show their shape. Don't be afraid of hard edges on clouds because this can often help a watercolour.

Second stage

I painted the background trees when the sky was dry. I used my No. 10 sable brush with a varied mix of French Ultramarine, Crimson Alizarin and Yellow Ochre, with a touch of Cadmium Yellow Pale. I then painted in the roof and chimney stacks using Cadmium Red and a touch of Cadmium Yellow Pale. When the background trees were dry, I painted the main trees with my No. 6 sable and rigger brush. Notice how I used a strong green on

Colours

Yellow Ochre

Crimson Alizarin

French Ultramarine

Cadmium Yellow Pale

Cadmium Red

Hooker's Green Dark

▼ First stage

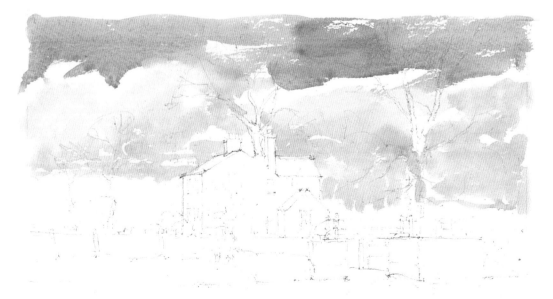

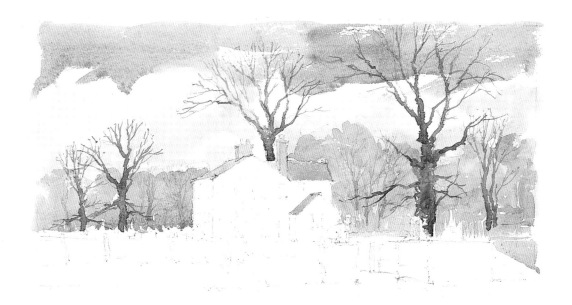

the large tree on the right to show sunlight. While I had green on the brush, I painted the little area of grass bank on the right side of the lock.

Third stage
Next, I painted the walls of the house with Cadmium Yellow Pale and a touch of Crimson Alizarin using my No. 6 sable brush. Then I did the green lawns with Cadmium Yellow Pale and a little Hooker's Green Dark, working down into the river bank. I painted the lock with Yellow Ochre and a touch of Crimson Alizarin. I also painted the green moss on the bottom of the walls. Next, with a wash of French Ultramarine, Crimson Alizarin and Yellow Ochre, I painted the shadow sides of the house. Then, making the same colour darker, I painted the shadow sides on the lock. I then darkened the river bank. Finally, still with my No. 6 sable brush, I painted in the windows and shadows on the chimney stacks and roof, and painted the small bush on the bank with my rigger brush.

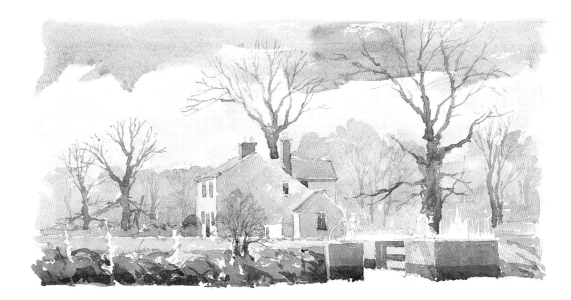

◀ Third stage

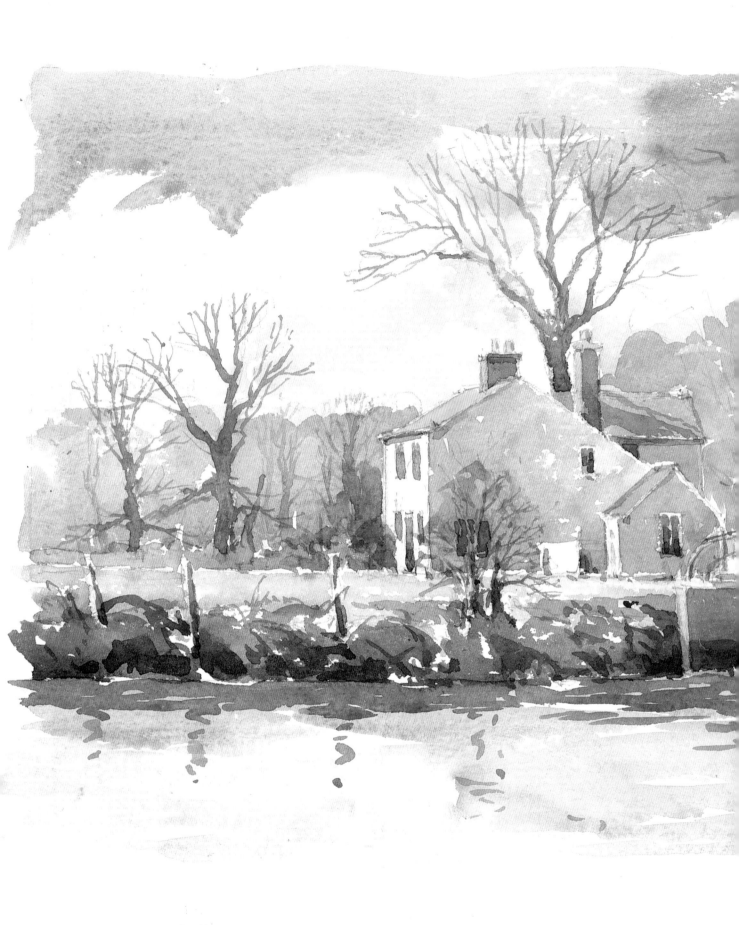

Finished stage

Now I painted the water with my No.10 sable brush, starting with a wash of French Ultramarine and a little Crimson Alizarin, adding Yellow Ochre and water as I worked to the bottom. As usual, this was done with horizontal brush strokes, leaving some unpainted areas for movement. I painted in the posts on the bank and the railings over the lock with my No. 6 sable brush, and suggested the railings on the right of the lock. Using the same brush, I mixed a wash with French Ultramarine, Crimson Alizarin and Yellow Ochre and painted in the reflections. Notice how simple they are – if you keep them simple, they will look more convincing. I then added some accents of dark paint where I felt it would help the painting. Notice how many accidental small 'chips' of white, unpainted paper there are over the whole of the painting. This helps to give light and energy to the painting.

▲ Detail from finished stage, reproduced actual size.

◄ **Dedham Lock**
watercolour on Bockingford
watercolour paper 200 lb Not
23 x 35 cm (9 x 14 in)

Painting from a Photograph

For this demonstration, I used a photograph of Venice taken on a painting holiday. It is a great one to work from, especially in watercolour. When you have done this, work from some of your own photographs – practise in the winter when you can't work outside!

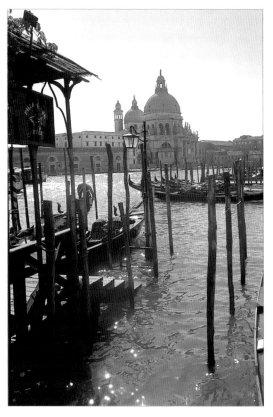

Let me say first of all that painting from a photograph is not a short cut to learning to draw or paint. A photograph is only an aid to painting, although it can be a very good one. If you accept this, you can use photographs to work from without feeling guilty, as many students do.

After all, put yourself in the position of the Old Masters. They couldn't paint at night because they had no electricity. Yet I am sure that, if electricity had been available to them, they wouldn't have shunned science – they would have turned on the light and worked at night. Similarly, I am sure that, if the camera had been invented then, they would have taken photographs to use for reference alongside their sketches when working in the studio. So let the camera become just another tool, along with your sketchbook, modern nylon brushes, learn-to-paint videos, books, and so on.

Do a pencil sketch first

Photography has its part to play, but take note – a photograph always flattens the middle to far distance, making it look smaller and insignificant. When we look at the same view, our eyes can unconsciously enlarge the middle distance and we then see it in isolation; it fills our vision. When you work from a photograph, you should keep this in mind. The best way to work is to draw a pencil sketch of a scene, then take a

photograph. You will see the difference between your eye's image and that of the camera, and that experience and knowledge will help you. Most important of all, don't copy a photograph slavishly. You must simply use it as a guide to painting your individual masterpiece, in your own style.

One last important point – you must try wherever possible to take your own photographs to copy from. This means you have experienced the real scene.

Colours

French Ultramarine

Crimson Alizarin

Yellow Ochre

Coeruleum

Cadmium Yellow Pale

Hooker's Green Dark

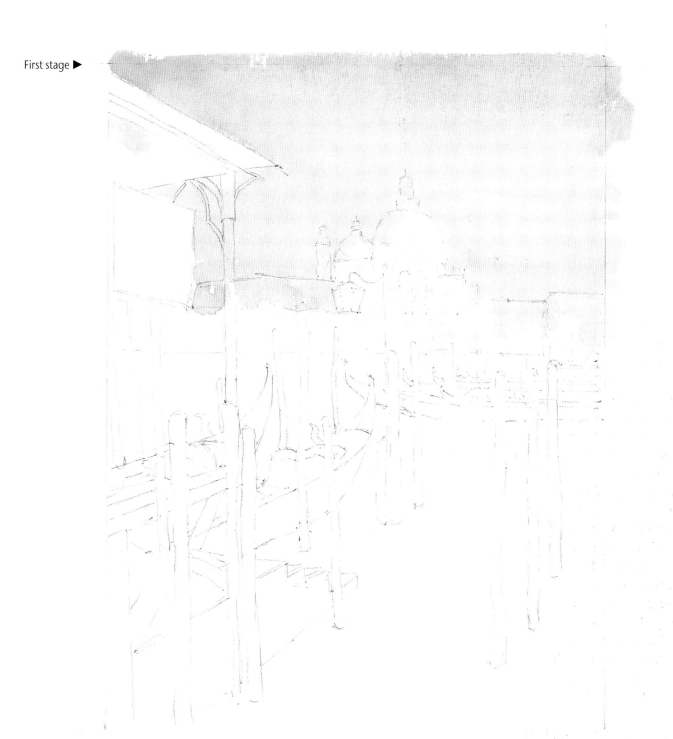

First stage

I drew the scene with 2B pencil. To begin with, look at the photograph carefully and compare it with my finished painting on page 64. You can see that I have left out all the detail in the buildings at the back, helping to keep them in the background. I also moved the posts with the lamp on so they didn't cover the end of the first gondola, and lowered the post under the lamp to make the lamp more important. I

moved some of the posts, to make the painting read better, and exaggerated the warm light on them to create the feeling of late afternoon sunlight. I couldn't see from the photograph what was happening on the gondola on the far left, so I made it simple, which actually helped the painting. I painted the sky down to and into some of the background buildings with a wash of French Ultramarine and Crimson Alizarin, then added Yellow Ochre for the rest of the sky.

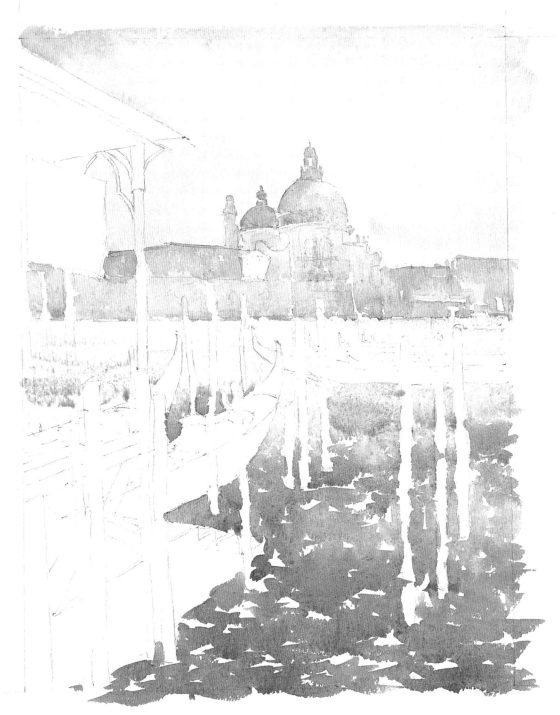

Second stage

When the sky was dry, using a varying mix of French Ultramarine, Crimson Alizarin, Yellow Ochre and plenty of water, I painted in the background buildings. When you do this, let the colours run together – wet-on-wet. I did this with my No. 6 sable brush and also used the same brush and technique to do the water. Then, with a wash of Coeruleum and Cadmium Yellow Pale, I started painting the water under the buildings and worked down, changing the colours gradually to French Ultramarine and Hooker's Green Dark, with a little Crimson Alizarin added in. You will see that I didn't attempt to put clean edges on the posts. Notice also the amount of white, unpainted paper I left for 'dancing light' on the water.

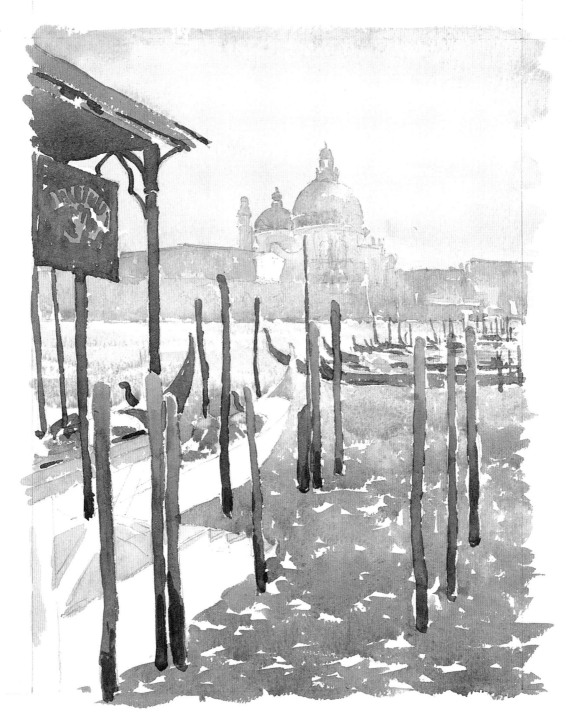

Third stage

Having let the water dry, I painted in the light colours on the gondolas and the 'black' of the hulls. All this stage was done with my No. 6 sable brush. The structure on the left and the posts were next. I started with the green top. Then I painted Yellow Ochre on the sign underneath this, adding more water. Next, I painted the top of the steps. When these were dry, I painted the very dark area under the green top, the sign, and the dark posts. Then, with a mix of Yellow Ochre, Crimson Alizarin and a touch of French Ultramarine, I started at the top of the light posts, letting the paint run wet-on-wet down them, getting darker towards the bottom.

63

Finished stage

I started by painting in the dark posts and gondola in the foreground. I added more darks to the posts at the bottom, using Hooker's Green Dark and Crimson Alizarin. Then, using the same colour and adding French Ultramarine, I painted in the reflections. This was done with broken, short brush strokes using my No. 6 sable brush.

I then painted in the lamp, and this helped to push the background buildings further back. Finally, I darkened under the green roof and the structures and posts. Remember, you can't paint any of these demonstrations exactly like mine, I couldn't do them exactly the same again, either. So, when you have finished a demonstration, add any darks or accent that will help *your* painting – but don't fiddle!

▼ **Venice**
watercolour on Bockingford watercolour paper 200 lb Not
30 x 23 cm (12 x 9 in)

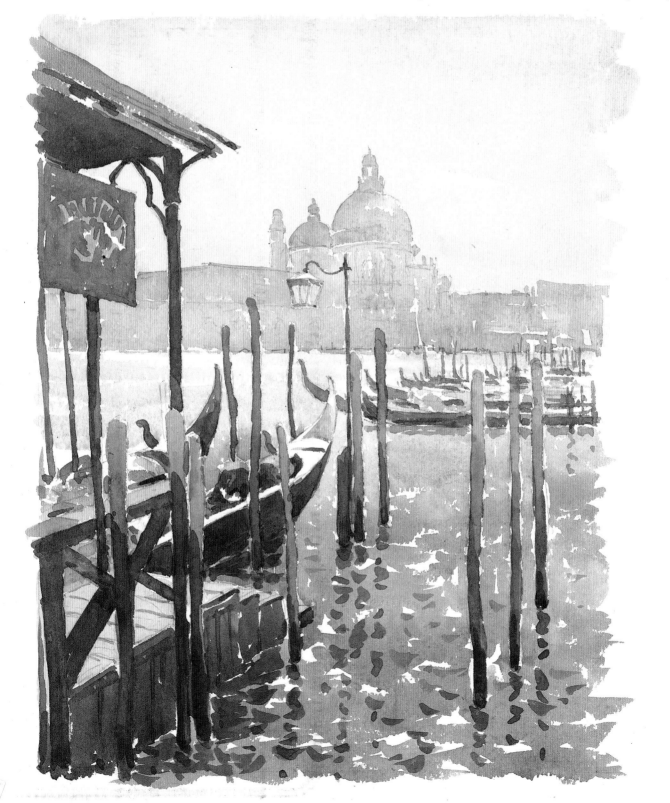